KU-770-973

2

Published and distributed by RotoVision SA
Route Suisse 9
CH-1295 Mies
Switzerland

Sales, Production & Editorial Office
Sheridan House,
112–116A Western Road
Hove, East Sussex, BN3 1DD, UK

Tel: +44 (0)1273 72 72 68
Fax: +44 (0)1273 72 72 69
Email: sales@rotovision.com
Website: www.rotovision.com

Copyright © RotoVision SA 2002

All rights reserved. No part of this publication
may be reproduced, stored in a retrieval system
or transmitted in any form or by any means, electronic,
mechanical, photocopying, recording or otherwise,
without permission of the copyright holder.

ISBN 2–88046–643–1

10 9 8 7 6 5 4 3 2 1

Written and Designed by PAUL FARRINGTON/STUDIOTONNE
Project editor GILES LANE
Commissioning editor KATE NOËL-PATON

Production and separations by
ProVision Pte. Ltd., Singapore
Tel: +65 334 7720
Fax: +65 334 7721

RotoVision

INTERACTIVE

THE INTERNET FOR GRAPHIC DESIGNERS

**Books are to be returned on or before
the last date below.**

2 8 APR 2008

Glamorgan Centre for
Art & Design Technology

Glyntaff Rd, Glyntaff,
Pontypridd CF37 4AT
Tel: 01443 662800

089362

Two years ago I got *INTERACTIVE* with my partner: the experience became reality and my little daughter was born. Thanks for looking after me when I didn't allow myself to sleep and for having pixel eyes – love to Mags, Lily and my amazing parents who give so much.

THE DIGITAL CONNECTION

AS PART OF THIS BOOK'S ONGOING COMMITMENT TO
EXPLAINING INTERACTIVE DIGITAL CREATIVITY, THERE IS
A WEBSITE AT WWW.INTERACTIVEBOOK.NET, DESIGNED TO
ACT AS A BRIDGE BETWEEN THE WORK WITHIN AS EXPLAINED
IN PRINT AND ITS ACTUAL DIGITAL PRESENCE.

USE THE WEBSITE IN CONJUNCTION WITH THE BOOK TO
VIEW WORK FEATURED THAT IS NOT INTERNET-SPECIFIC
AND MIGHT ONLY BE ACCESSIBLE AS CD-ROM. SMALL
DOWNLOADS ARE AVAILABLE AND LINKS OFFER OTHER
POSSIBLE EXPLORATIONS. VISUAL INTERPRETATIONS
AND HYPERLINKS ALSO EXPLAIN THOSE TERMS PARTICULAR
TO THE INTERNET AND INTERACTIVE DESIGN, AND THESE
ARE GRAPHICALLY LINKED BY THE 'WWW' ICON TO THE
ALPHABETICALLY-ORDERED EXPLANATIONS OF TERMINOLOGY
THAT RUN THROUGHOUT THE BOOK.

THE TERMINOLOGY

THIS IS FURTHER CATEGORISED THROUGHOUT BY ICONS AS
INDICATED BELOW AND IS ALSO COLLECTED AS A GLOSSARY
ON PP156-157.

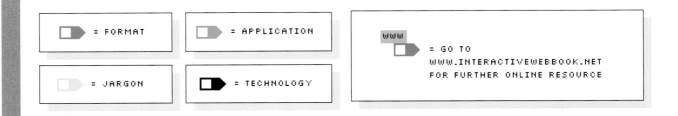

= FORMAT

= APPLICATION

= JARGON

= TECHNOLOGY

WWW = GO TO
WWW.INTERACTIVEWEBBOOK.NET
FOR FURTHER ONLINE RESOURCE

SHIFTING VISIONS

With a shift in graphic communication from print to digital environments, the challenge for today's graphic designer is to address how graphic content is designed, displayed and structured for use on the worldwide web and other network interfaces. The web in particular is a hybrid of media and modes of expression: art, illustration, photography, typography, animation, film, sound, text, music, etc; all are accessible as tools for the designer to use. In turn, the more varied use of these skills and techniques is developing new methods of conveying communication digitally.

This book's intended audience is graphic designers who come from a background in print and other communications media, and who realise the importance of designing for network media, both for the client and from their own desire to explore a new path for artistic expression. This book might also be useful to someone who is involved in new media, but hasn't had any formal graphic training. The book is not a manual for showing you how to design for new media since it's not a science; nor can it be taught at design school. The conditions and many languages of programming are clearly the building blocks for learning, but you cannot teach someone to be intuitive or to instinctively draw upon a wide range of influences.

As a visiting lecturer of interactive design, my aim in the classroom is to inspire my students to find something in themselves that gets them out of bed in the morning. Sometimes it is design, sometimes it is music, sometimes being at college is enough. Some designers can automatically fall into web design; for instance, I have noticed sometimes that students who have a science or maths background make good programmers and designers. Designer and programmer working relationships are common.

This book doesn't just look at the internet to gain an understanding of this space, it also reviews other networked environments such as CD-ROMs, installations and handheld network devices, for these all deal with forms of navigation. Whether designing for the internet, a CD-ROM or an installation, the starting point for any design process is to address the navigation of content, how the user will make full use of its intended application and how the information is visualised. Designers cannot just think about design in two-dimensional formats any more. The challenge for the design brief today is that much – if not all – design has to be applied to a cross-media system: print, web, television, mobile, handheld, portable and networked applications.

DESIGN PROFESSIONALS DESCRIBE HOW THEY
VIEW THE ROLE OF THE (PRINT) GRAPHIC
DESIGNER WHO WORKS IN THE WEB ENVIRONMENT...

IN MY OPINION YOU CAN'T DESIGN
A WEBSITE IN QUARK AND GIVE
IT TO A PROGRAMMER TO 'MAKE IT
WORK'. IT HELPS TO HAVE AN
UNDERSTANDING OF THE DIFFERENT
BROWSERS, HOW SEARCH ENGINES
HARVEST THEIR DATA, ETC. ALSO,
IN WEB WORK THERE'S AN INFINITE
AMOUNT OF TEDIOUS REPETITIVE
WORK: AUTOMATION, DATABASES AND
SCRIPTING ARE THE ANSWER, BUT
THEY NEED TO BE BUILT IN RIGHT
FROM THE START BY THE DESIGNER,
NOT AFTER THE FACT. WEB DESIGN
IS NOT MAKING A SCREENSHOT
OF A POSSIBLE FRONT PAGE, IT'S
MUCH CLOSER TO THE PROCESS
OF SOFTWARE DEVELOPMENT.
ERIK VAN BLOKLAND, LETTERROR

MANY GRAPHIC DESIGNERS USED
TO PREFER (OR TRY) TO ACHIEVE
THE SAME RESULTS AS PRINT ON
THE SCREEN, SO I AM A LITTLE
NEGATIVE ABOUT THOSE PEOPLE
WHO USE COMPUTERS TO DESIGN
AND COMPLAIN ABOUT THE RESULTS.
BUT IT SEEMS TO HAVE CHANGED
NOWADAYS. THERE ARE MANY GRAPHIC
DESIGNERS WHO ARE AWARE OF THE
DIFFERENCE BETWEEN THE NATURE OF
PAPER AND SCREEN. I REALISED THAT
THE TOOL OR SKILLS OR BACKGROUND
DOES NOT MATTER AS LONG AS ONE
CAN COME UP WITH STRONG IDEAS.
PHILIP O'DWYER, STATE DESIGN

THE BACKGROUND TO THIS BOOK

I encountered the worldwide web while at college; at that time, no one knew what it was. We could all grasp that the computer was an important tool in the design studio – but getting to understand it also became a challenge, one that I am glad I tackled.

Everyone expects you to draw when you are a designer. However, I could never express myself through drawing, so I always turned to photography, image-making, letterpress and mixed media for inspiration. If I had a graphic assignment, I would always use a familiar physical process (photography, illustration), which sometimes resulted in mistakes that I could learn from and develop as my own personal method of production. My work has never been driven by a formula or an adopted system; each design is governed by the material, the technology, the budget and limitations and aspirations of the client and user.

A system isn't there to be slavishly learnt and rigidly applied, but to be adapted and made personal, developed by each person to find their own way of working with it. I came to the computer out of a desire to learn and then to experiment; for example, taking photographs, scanning them in, taking them into Photoshop and lowering the resolution, and then printing them out only to repeat the process again and again. Doing exercises like this allows a designer to learn and develop their own computer-based methods.

The first interactive work I did involved recording music through the computer's microphone. Through sampling and playing with music, I began to experiment in the same way as I did with my image-making. A friend then showed me an interactive application (then in its early days) called Director, with which sound and image could be combined to make a little movie. Later on, I began to sample computer code and use this in the same way as I would an image.

I didn't simply wake up one day and start to design for the internet – it happened over time. My understanding of design for the internet has been progressive. However, I would never call myself a web designer, but a designer who is adaptable to changes in media. At the heart of internet design has to be an understanding of communication – an understanding that isn't only about how the message is translated, but also the creative decisions that the designer has to address. Issues such as the legibility of typeface and ease of reading become ever more important as we witness design that attempts to entertain the user while informing and holding their attention before they click and venture elsewhere. We also need to be able to design by application: to understand the software, and to know how to use it.

Communication deals with the associations we make between word, symbol and image. The end result is often very stale in its delivery. This is not to say that the delivery of the same message on the internet can be made any better just because we view it on our new flat screen. But by employing modes of entertainment such as those found in film (sound, motion and narrative), the medium through which the message is received can be enhanced. Many people find it very easy to sit down and watch four or five hours of television, but this is not always an activity that demands high concentration. We might also read a newspaper on the way to work in the morning – again, what matters is not so much the information that we receive as the way in which it is conveyed: often it is the images that grab and hold our attention.

INTERACTIVE deals with the cross-over in design from print (physical) to the internet (digital) and is intended to engage, inspire and question the role of the designer. The thrust of the book is not to insist on knowing everything about the internet, but to engage with the medium. It is important for the graphic designer who moves into internet design from print to learn and understand the basic properties of networks and the properties of the screen. Once an understanding of these is grasped, the wider realms of web development software and application programming stretch out before you like a vast plane.

THE STRUCTURE OF INTERACTIVE

Each section in this book attempts to examine different aspects of designing for interactive media and the internet – from an assessment of the different kinds of environments that constitute network media in A HYBRID SPACE, to working methods and processes employed by designers in DESIGN METHODOLOGIES. These are supported by a chapter dealing with commercial and experimental projects – IDEAS, PROJECTS & SCENARIOS. This allows the reader to look into how a particular site was designed, how it functions, and why particular technologies were employed to create it. Finally, INFLUENCE presents a series of spaces in which a selection of designers explore the notion of what digital space is, how the 'feeling' of digital can be expressed in a print context, how navigation can be visually represented in a book and how programming can be used to generate typeface designs.

For the graphic designer new to the internet, INTERACTIVE highlights designers, artists and programmers who have arrived at internet design from diverse disciplines, and looks at how they adapt their working methods for the internet. The book demonstrates how relationships between designers and programmers work, how design companies and artists merge print and the internet as a union of shared media, and also profiles designers whose background is in internet design alone.

GO TO >>> 84

DESCRIPTION

PROJECT: INTERACTIVE MUSIC
CLIENT: WILDLIFE RECORDS
DATE: 2000
DESIGN AND PROGRAMMING:
ROM AND SON
TECHNOLOGY: DIRECTOR SHOCKWAVE
FORMAT: ENHANCED CD-ROM

CREATIVE INSPIRATIONAL THINKING IS THE MOST
IMPORTANT PREREQUISITE TO WORKING AT DIGIT.
WHILST HAVING WEB/DIGITAL SKILLS IS A CLEAR
ADVANTAGE, IT'S NOT ESSENTIAL. WE VIEW ANYONE
WHO HAS STRONG CREATIVE THOUGHTS AS ESSENTIAL
TO DIGIT, WHETHER THEY BE PRINT DESIGNERS,
PROGRAMMERS OR PRODUCERS. TEACHING PEOPLE
HOW TO BUILD WEBSITES IS THE EASY BIT.
DIGIT

EXPLORING THE BOUNDARIES OF INTERNET DESIGN

Today's internet designer is working within a hybrid of artistic and creative digital media, creating overlaps and mergers between art, illustration, photography, typography, animation, film, sound, text and music. Out of this rich mixture, new methods are produced that give rise to a wide range of creative and fun possibilities for the designer. For example, designs are made where logos are animated and mouse clicks activate sound to enhance the user's experience.

With web design being the client's latest marketing requirement, today's designers are having to learn new methods and skills of production to enhance their creative output. Technical jargon, software advancements and the range of skills needed to produce a website leave beginners puzzled as to where to begin. A need to start somewhere may mean turning to books and magazines that provide advice and tutorials on how to design for the web by using HTML (hypertext mark-up language) or applications such as Flash or Shockwave plug-ins, which can allow for more interactive content.

As skills overlap and merge, design companies form from a diverse range of backgrounds: from product design, psychology, writing, technology, programming, fine art and film. When people from different backgrounds come together in a studio a certain dynamism is generated. Rom and Son is a design group with clients in both the commercial and cultural sectors, including Paul Smith, Benetton, The Science Museum and Mitsubishi. The studio is made up of fine artists, designers, musicians and illustrators. One of the projects to come out of this hybrid approach was the enhanced CD-ROM for Wildlife records. This demonstrates how playfulness can produce work of such sophisticated layering that it can only be realised in the digital space. In the work, the user makes music by pressing the keys of a standard computer keyboard. The project's designers (who are not musicians) have produced a work that combines design, music and programming and that makes the CD-ROM format come alive.

The 'industrious clock' on WWW.YUGOP.COM uses the flicker of Super 8mm film and the image of a hand drawing numbers on to paper, each image changing in unison with the computer's clock. What is striking about this work is how simple it appears and how beautiful it is to watch, while, underneath, the programming is complex and invisible.

WWW.YUGOP.COM

DESCRIPTION

PROJECT: INDUSTRIOUS CLOCK
CLIENT: COMPANY WEBSITE
DATE: ONGOING
DESIGN AND PROGRAMMING: YUGOP
TECHNOLOGY: DIRECTOR SHOCKWAVE
FORMAT: WEBSITE/DESIGN PORTAL

▶ **A HAPPY NEW YEAR.** INDUSTRIOUS 2001. MONO*CRAFTS 3.0

YEAR: **2001**

DAY: **02**

HOUR: **11**

MIN: **12**

SEC: **03**

AUTONOMOUS ENVIRONMENTS:
USING THE INTERNET AS A SPACE FOR SELF-EXPRESSION

There is no right or wrong way to design for the internet, there is only your own way – following the path you have constructed and deciding if it feels right.

The internet experience needs to be fresh, rich, surprising and as original as possible. The delivery of content has to be made simple and easy to understand, because today's consumer requires more than the average website. With the current boom in companies marketing themselves on the internet, a need to stand out from the crowd is crucial to the client, and therefore to the designer.

A great deal of time is spent in research, with designers, technologists and programmers exploring new ways to address questions such as: what is it to actually navigate a website? How can surfing be made more friendly? More intuitive? More physical? How can text be displayed on a screen so that reading it is more pleasant? The results from this research are varied, from the abstract to the straightforward.

With the freedom that the internet gives us, publishing work encourages debate and questions the role of artistic authorship within the digital space. This makes the internet an autonomous environment for designers to work in, allowing work to have its own visual language and structure.

Websites that are designed to make you think and question the direction of communication have an enormous influence when tackling design challenges in the commercial sector. The scope of environments envisaged here has more to do with architectural spaces than translating the systems we understand in print. An example of this is WWW.NOODLEBOX.CO.UK, a site that is beautiful in its ideas, design, use of colour and its generally playful feel. In a way, the site has no real purpose other than as a playground for creative experiments, but this is exactly why the site works so well: it's about having fun and enjoying the web experience. Every stage is well conceived, even down to the loading screens. The user even gets to design their own navigation control by moving the building blocks of the site around into any configuration they wish. It remains one of the few creative sites that compels one to return again and again for engaging ideas and to explore the possibilities of navigation.

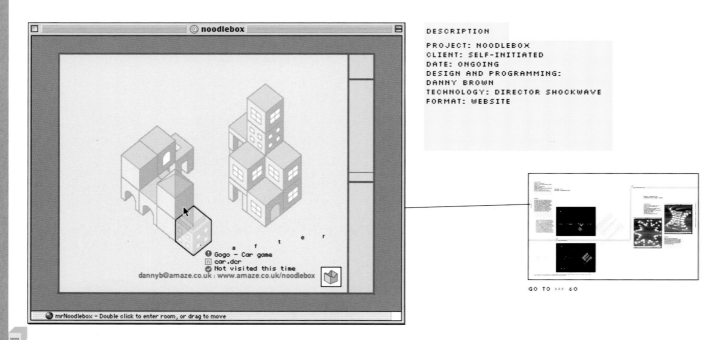

DESCRIPTION

PROJECT: NOODLEBOX
CLIENT: SELF-INITIATED
DATE: ONGOING
DESIGN AND PROGRAMMING:
DANNY BROWN
TECHNOLOGY: DIRECTOR SHOCKWAVE
FORMAT: WEBSITE

GO TO >>> 60

CREATIVE DISCIPLINES
COMBINE TO SHAPE THE INTERNET

The experience of visual culture actually engaging in its appearance sometimes goes unnoticed; life moves so fast, and the internet moves even faster – websites can often be automatically updated every second. There are few markers that exist to show this movement, so this book is also an attempt to fix a moment of the interactive space we work in and make a selection of interactive design work visible to the human eye and history.

Print and graphic design now crosses over into internet environments, but how can work be made where the print matter doesn't just get pasted into a webpage? Can these two branches of design – print and internet – work in unison? Is it possible to make work that sits comfortably on a screen as well as on the cover of a book? How is the user experience of navigating through an internet space structured and designed? INTERACTIVE confronts these and other related issues, seeking to present solutions found in actual design practices rather than developing a specific theory.

Physical objects also play an important role in the development of interaction design and user experience. Microphone Fiend is a CD-ROM made by Tota Hasegawa while on the Computer Related Design course at the Royal College of Art in London. It captures the childlike nature of computers and game playing, with the innocence of participation in a fun interaction. In this work, the user is presented with a microphone that controls the loading screen, the interface, and the way each interaction is used. By blowing into the microphone, the user can 'light' and 'extinguish' matches, or play animated film strips forwards and backwards.

GO TO >>> 120

"Do you want to quit?"

DESCRIPTION

PROJECT: MICROPHONE FIEND
ACADEMIC WORK:
PRODUCT VERSION PUBLISHED
DIGITALOGUE 1999 FROM STUDENT
VERSION PUBLISHED RCACRD 1996
DATE: 1996–1999
PRODUCT, DESIGN AND
PROGRAMMING: TOTA HASEGAWA
TECHNOLOGY: DIRECTOR MOVIE
FORMAT: CD-ROM
WEBSITE URL: WWW.TOTA.NE.JP

WE PREFER DESIGNERS THAT HAVE HAD A BACKGROUND IN PRINT DESIGN IN THE STUDIO. NORMALLY, THERE IS A MORE THOROUGH UNDERSTANDING OF CORE DESIGN PRINCIPLES FROM DESIGNERS THAT HAVE COME FROM THE PRINT WORLD.
KEVIN FARNHAM, METHOD

Print designers working on internet design often take the conventions and rules of print design into the screen's interior as opposed to taking inspiration from other physical objects (ie, architecture, building plans, signage, etc) and remodelling them into something new. If we leave the texture and smell of print behind, can we take influence from the screen environment, being inspired by pixels rather than paper and ink?

Web design has made print designers rethink their attitude towards print design. New methods are being produced that take influence from websites – their navigation, the readability of text and the resolution of images. Within navigation, designers are dealing with the issue of readability of information by looking at how the text can be laid out and read. Typefaces are being designed that echo the screen's pixel-based quality.

As images are now almost exclusively transmitted in digital formats, designers are experimenting with the texture of low-resolution images and high-resolution images together. The web has given us new methods to express how content can be made visually engaging to read.

A new understanding of clarity of information has come from this convergence of sound, text, imagery and moving image. It is no longer structured around the sharpness of what is represented in an image, but the mode in which it is communicated. Thus we bring the 72dpi resolution into the print environment.

Typography has often been inspired by pixel-based displays. For instance, Pixel Crude is a typeface that was designed by Cornel Windlin and Gilles Gavillet in 1999. It has the feeling of early bitmap games and screen resolutions, and forms part of a dialogue between print and digital media.

Taking direct inspiration from technology, the artist and designer John Maeda programs and designs his own software, which he uses to create powerful graphic statements that merge programming and graphics in a seamless visual unison. Printed with the decoration of metallic inks on uncoated and recycled papers, the outcome is visually original both in its graphic production and appearance. His work challenges the boundaries of conventional print design by reinterpreting it from the standpoint of a specifically digital medium.

DESCRIPTION

PROJECT: PIXEL CRUDE
CLIENT: GAME_OVER
DATE: 1999
DESIGN: CORNEL WINDLIN,
GILLES GAVILLET
FORMAT: TYPEFACE
WEBSITE URL: WWW.LINETO.COM

THE KEY TO BUILDING A GOOD SITE IS TO CONSIDER THE USER.
PRINT DESIGNERS TEND TO INITIALLY DESIGN SITES THAT LOOK GOOD,
BUT ARE HARD TO USE. KEEPING THINGS SIMPLE AND STILL RETAINING
A PLAYFUL APPROACH TO NAVIGATION IS VERY IMPORTANT.
ANTHONY BURRILL

DESCRIPTION

PROJECT: BUSABA WINDOW DISPLAY
CLIENT: ALAN YAU, BUSABA
DATE: 2000
DESIGN AND PROGRAMMING:
ROMANDSON, TOMATO INTERACTIVE
TECHNOLOGY: DIRECTOR,
CUSTOM-MADE CAPACITANCE SENSORS
FORMAT: GENERATIVE SOUND SYSTEM
LOCATION: BUSABA RESTAURANT,
LONDON, UK
WEBSITE URL: WWW.ROMANDSON.COM,
WWW.TOMATO.CO.UK

GO TO >>> 85

IS THE INTERNET A RESTRICTIVE SPACE?

The internet is often criticised by print designers as being restrictive and not containing the freedom that print offers. In fact, it offers greater scope than print has ever achieved. Print can be restrictive in the delivery of a message; its audience is restricted by location and the timescale of a project. On the web, advertising billboards are replaced by web banners, and huge numbers of people almost anywhere in the world can view the work with just a computer, modem and an internet connection.

Print advertising is largely a one-way relationship in which, surrounded by a barrage of slogans and images, we see a poster or a magazine advert and absorb the message without really engaging or paying attention to it. Television commercials also are beamed into our homes every fifteen or thirty seconds, but barely register as we flick the channel or get up to make a cup of tea, then settle back down to watch the programme that they interrupted.

The internet, however, presents far greater scope for developing interactive and reflexive relationships with users that goes way beyond just advertising a product or a service. The possibilities of engaging users in scenarios or games (such as the Nokia Game) that provide a whole brand experience are vast, and as yet only barely explored. The internet is not just a space in which advertising companies can learn more about consumers, but one in which new forms of relationship between consumers and the brands they choose to buy can be invented from scratch.

Interactive branding gives freedom to the designer to make full creative use of the media. It also gives authorship to the designer, where communities and thinkspaces can be created. The restaurant Busaba in London's Soho uses digital technology to entice passers-by into the restaurant. Designed as a series of self-generating images that respond and produce sounds as customers pass by the window, these immediate graphic displays enhance an often dull environment. What if models of this nature could transcend to the web environment? In theory, it is still web design, as it was created with the tools for the screen, but by changing the context of the medium it takes it somewhere more interesting.

These solutions create spaces where graphic messages engage the user, making them part of the same space; and so new realities are born. As digital space becomes 'physical' and our senses enjoy the challenge of making sense of the virtual, could it be that sound becomes the texture for digital media in the same way that smell and touch define print?

A HYBRID SPACE

A HYBRID SPACE
INTERNET DESIGN IS AS DIVERSE AS VISUAL CULTURE

The rapid expansion of digital networked technologies has seen an unparalleled growth of technique combinations and tools for designers to play with. Networked media present a vast series of new spaces for graphic design that are not limited to two-dimensional formats such as posters and flyers. The overlap between graphic design and design for new media creates challenges to which designers need to respond through innovation and by widening the scope of their influences to incorporate other creative practices.

Networked media are the catalysts for the creation of different environments for communication – visual, aural and tactile – and designers need to be involved in the whole process rather than just focusing on the flat screen. How designers engage with the enormous possibilities offered by virtual space – what lurks beneath the surface of the screen – will become the defining mode of what could be seen as an emerging new approach to the concept of graphic design as a discipline. Graphic design is no longer limited to print: its role has changed and has to change further. Designers need to rethink their attitudes and embrace new methods of practice.

Influences should come from a broad range of practices: architecture, experimental music, photography, art and other branches of creativity. The reason for such a diverse range is that graphic designers need to be aware that they are not just designing for the web, but a whole host of screen-driven media, such as mobile phones and handheld computers. There is a need to look beyond the browser and get to grips with different media, particularly those that create new associations between communication and technology. The new century has ushered in the beginning of a great convergence of the technologies of communication.

In this space of overlapping technologies, graphic designers need to broaden their outlook to take in the new media horizon. It is possible for them to do more with the processes of interactive digital media than is perhaps possible with traditional print media. Not only can they take off-the-shelf software solutions and manipulate them, but they can also delve into the more arcane areas of programming and become involved in the development and adaptation of networked interaction themselves.

It is clear that we are still only in the very early days of networked media, and the hype of the companies building the different networks that are coming to interweave with each other is often misleading and geared to specific commercial outcomes. However, as designers play with these new media, new forms of expression appear, new ways of making a message, new ways of communicating a thought or a feeling. The climate that this heralds is one of change and discovery: new spaces allow for design to be active in more than one medium, and they create a need to design and develop information and navigation systems that work together across the formats of print, internet, wireless communications and television.

The terrain of graphic design is no longer simply the look and feel of a product or a service, but what underlies the mode in which it communicates. New languages of interaction are being created by the very media we surround ourselves with in our daily lives, and in turn they are being used and adapted to make new spaces and meanings of our interactions with each other and the world around us. Designers are among the chief protagonists in making these new forms of expression and communication intelligible and useful to people in their daily lives.

THE NETWORKED SPACE OF GRAPHIC DESIGN IS NO LONGER SIMPLY THE LOOK AND FEEL OF A PRODUCT OR A SERVICE, BUT WHAT UNDERLIES THE MODE IN WHICH IT COMMUNICATES.

As the physical manifestation of graphic design becomes less and less tangible, as it becomes ever more deeply embedded within the process of communication, designers need to seek out new means of orchestrating the information they are giving form to. Often the computer is invisible – we do not see the processes going on, the communications behind every transaction. For instance, at the cash machine when we withdraw money, our sole interaction with the bank is the way in which we are guided to navigate through the options presented to us. Traditionally, these transactions are cold – a series of yes/no choices with little or no sense of human interaction. It will increasingly become the task of the designer to find new and more intuitive ways of engaging users, not just at the cash machine, but wherever they are interacting with such systems – whether it is done via the web, on a mobile device or a telephone.

A key means of structuring interaction is familiarity and difference – designers will need to be able to adapt their skills to work across a broad range of technologies and media, building processes and structures rather than identities. The measure of radical design will be its ability to work seamlessly, if differently, across such media and devices. Users will come to appreciate not only the look of a design, but also how it feels in terms of the way in which their interaction with it is structured. Such an interaction might not be smooth and simple, but ragged and challenging – the palette of available techniques is almost infinite. What designers will be providing is new ways in which to experience the processes of communication.

Shopping via the internet is now becoming a more regular feature of people's daily lives – though it is really divided into two very different kinds: finished goods and services, and perishables like food. Buying books, electronic items, airline and cinema tickets have become familiar, but using the new networked media of the internet to buy things like food is still in its infancy. In some ways, it harks back to the days when butchers' and bakers' vans delivered their goods, and when milk floats were seen every morning as people went to work or school. In other ways, shopping via the internet is a cold experience – we give up the handling and personal selection of food items to a nameless, invisible packer. It is perhaps the major challenge for design to create new modes of interaction that will shape and structure the way in which we buy things in the future.

The work presented in this chapter proves that designing for the internet is as diverse as visual culture. Graphic design is about being adaptable to change depending on its application. Increasingly, the design solution has to work in harmony across many media: print, internet, television, etc.

DESCRIPTION

PROJECT: METHOD.COM
CLIENT: COMPANY WEBSITE
DATE: 2000-ONGOING
DESIGN AND PROGRAMMING: METHOD
FORMAT: WEBSITE/DESIGN PORTAL

CONCEPT

Method is an interdisciplinary firm with expertise across a broad range of areas. They design intelligent, custom-built communication solutions for analogue and digital media. Method's solutions are the result of collaborations between strategists, researchers, designers and technologists.

METHOD
TYPOGRAPHY

GO TO >>> 86

San Francisco designers Method strip away all the gloss of internet design to provide a site that utilises a typographic hierarchy that is simple and clear. The combination of typography and programming allows Method to create designs that work happily both in print and on screen. The main image on this page is the programming that describes how the Method website is to be viewed on the internet.

The screengrab pictured right from their website shows their mission statement: 'Method is a design firm. We solve information and communication problems across a broad range of media. We call these integrated solutions design systems.'

GO TO >>> 96

```
<!DOCTYPE HTML PUBLIC "-//W3C//DTD HTML 3.2 FINAL//EN">
<HTML>
  <HEAD>
    <META HTTP-EQUIV="CONTENT-TYPE" CONTENT="...IS 859-1">
    <TITLE>METHOD</TITLE>
    <SCRIPT LANGUAGE="JAVASCRIPT">
    <!--
    FUNCTION SETSTYLE(){
      VAR PLATFORM
      IF (NAVIGATOR.USERAGENT...)
        VAR PLATFORM =
      } ELSE {
        VAR PLATFORM = "PC";
      }
      IF (NAVIGATOR.APPNAME.INDEXOF("MICROSOFT") != ...){
        VAR BROWSER = "IE"
      } ELSE {
        VAR BROWSER = "NS"
      }
      IF (PLATFORM == "MAC") {
        IF (BROWSER == "IE"){
          DOCUMENT.WRITE('<LINK REL="STYLESHEET" TYPE="TEXT/CSS" HREF="IE.CSS">')
        } ELSE IF (BROWSER == "NS") {
          DOCUMENT.WRITE('<LINK REL="STYLESHEET" TYPE="TEXT/CSS" HREF="NS.CSS">')
        }
      }
      IF (PLATFORM == "PC") {
        IF (BROWSER == "IE"){
          DOCUMENT.WRITE('<LINK REL="STYLESHEET" TYPE="TEXT/CSS" HREF="IEPC.CSS">')
        } ELSE IF (BROWSER == "NS") {
          DOCUMENT.WRITE('<LINK REL="STYLESHEET" TYPE="TEXT/CSS" HREF="NS.CSS">')
        }
      }
    }
    SETSTYLE()
    FUNCTION DISPLAY(URL,NAME,W,H) {
      MEDIUMWIN = WINDOW.OPEN(URL, NAME,'RESIZABLE=0,SCROLL...S=0,WIDTH=' + W + ',HEI...
      MEDIUMWIN.FOCUS();
    }
    // -->
  </SCRIPT>
  </HEAD>
  <BODY BGCOLOR="#000000" LINK="#999999" VLINK="#666666" ALINK="WHITE" VLINK="WHITE" TEXT="...CCCC">
    <!--HEADER-->
    <BR>
    <TABLE BORDER="0" CELLPADDING="0" CELLSPACING="0" WIDTH="550">
      <TR>
        <TD VALIGN="TOP" WIDTH="200"><DIV CLASS="LINK">METHOD /</DIV></TD>
        <TD VALIGN="TOP" WIDTH="350"><DIV CLASS="HEADER"> </DIV></TD>
      </TR>
    </TABLE><BR>
    <TABLE BORDER="0" CELLPADDING="0" CELLSPACING="0" WIDTH="735">
      <TR>
        <TD BGCOLOR="#666666" HEIGHT="1"><IMG SRC="IMAGES/SPACER_GIF..T="" WIDTH="2" HEIGHT="1"></TD>
      </TR>
    </TABLE><BR>
```

ADOBE ACROBAT: AN APPLICATION ALLOWING FILES TO BE READ IN THE PDF FORMAT. PDF (PORTABLE DOCUMENT FORMAT) WAS DESIGNED BY ADOBE TO ALLOW LARGE GRAPHIC FILES TO BE HIGHLY COMPRESSED FOR DISTRIBUTION VIA THE INTERNET.

WWW.METHOD.COM

Method /

Services
Clients
Case Studies
Company
Contact
Method Lab

Method is a design firm. We solve information and communication problems across a broad range of media. We call these integrated solutions design systems.

Identity / Communications Design / User Interface /

Recent Projects News

Gucci.com 10.02.01 Method wins 3 awards in 2001 West Coast Show
Embarcadero Technologies 09.27.01 Method awarded contract with Tsunami Fund
Groundwork 09.22.01 Method awarded contract with Consumer Electronics Assoc
The Remedi Project: Like Me More News

Method

info@method.com © copyright 2001, Method, Inc

```html
<A HREF="METHOD/SERV.HTML">SERVICES</A><BR>
<A HREF="METHOD/CLIE.HTML">CLIENTS</A><BR>
<A HREF="METHOD/CASE.HTML">CASE STUDIES</A><BR>
<A HREF="METHOD/COMP.HTML">COMPANY</A><BR>
<A HREF="METHOD/CONT.HTML">CONTACT</A><BR>
<A HREF="JAVASCRIPT:DISPLAY('METHOD/METHODLAB/METHODLAB.FLA...HECK.HTML','LAB',732,550)">METHOD LAB</A></TD>
<TD VALIGN="TOP" WIDTH="535" COLSPAN="5">
<DIV CLASS="HOME">
<B>METHOD IS A DESIGN FIRM. WE SOLVE INFORMATION AND COMMUNICATION PROBLEMS ACROSS A BROAD RANGE OF MEDIA. WE CALL THESE INTEGRATED SOLUTIONS DESIGN SYSTEMS. <BR></B>
<BR>
<B><A HREF="METHOD/SERV_IDENTITY.HTML">IDENTITY</A> / <A HREF="METHOD/SERV_COMM.HTML">COMMUNICATIONS DESIGN</A> / <A HREF="METHOD/SERV_INTERFACE.HTML">USER INTERFACE </A> /</B><BR><BR></DIV>
</TD>
</TR>
<TR>
<TD VALIGN="TOP" WIDTH="200"><DIV CLASS="LINK">
 </TD>
<TD VALIGN="TOP" WIDTH="185">
<DIV CLASS="TEXT2"><B>RECENT PROJECTS</B><BR><BR></DIV>
<DIV CLASS="TEXT2">
<A HREF="HTTP://WWW.GUCCI.COM" TARGET=_BLANK>GUCCI.COM</A><BR>
<A HREF="HTTP://WWW.EMBARCADERO.COM" TARGET=_BLANK>EMBARCADERO TECHNOLOGIES</A><BR>
<A HREF="HTTP://WWW.GROUNDWORK2001.ORG" TARGET=_BLANK>GROUNDWORK</A><BR>
<A HREF="HTTP://WWW.THEREMEDIPROJECT.COM" TARGET=_BLANK>THE REMEDI PROJECT: LIKE ME</A>
<BR><BR>
</DIV>
</TD>
<TD VALIGN="TOP" WIDTH="20"> </TD>
<TD VALIGN="TOP" WIDTH="350" COLSPANNING="3">
<DIV CLASS="TEXT2"><B>NEWS</B><BR><BR></DIV>
<DIV CLASS="TEXT2">
10.02.01 METHOD WINS 3 AWARDS IN 2001 WEST COAST SHOW<BR>
09.27.01 METHOD AWARDED CONTRACT WITH TSUNAMI FUND<BR>
09.22.01 METHOD AWARDED CONTRACT WITH CONSUMER ELECTRONICS F...<BR>
<A HREF="METHOD/COMP_NEWS.HTML">MORE NEWS</A><BR><BR></DIV>
</DIV>
</TD>
</TR>
</TABLE>
<BR>
<BR>
<BR>
<BR>
<TABLE BORDER="0" CELLPADDING="0" CELLSPACING="0" WIDTH="735">
<TR>
<TD BGCOLOR="#666666" HEIGHT="1"><IMG SRC="IMAGES/SPACER.GIF" ALT=...
</TD>
</TR>
</TABLE>
<TABLE BORDER="0" CELLPADDING="0" CELLSPACING="0">
<TR>
<TD VALIGN="TOP" WIDTH="200">
<DIV CLASS="ID"><BR>METHOD</DIV>
</TD>
<TD VALIGN="MIDDLE" WIDTH="185">
<DIV CLASS="TEXT2"><BR> </DIV>
</TD>
<TD VALIGN="MIDDLE" WIDTH="185">
<DIV CLASS="TEXT2"><BR><A HREF="MAILTO:INFO@METHOD.COM">INFO@METHOD.COM</A><BR>...
<TD VALIGN="MIDDLE" WIDTH="185">
<DIV CLASS="LINK"><BR>&COPY; COPYRIGHT 2001, METHOD, INC</D...
</TD>
</TR>
</TABLE><BR>
</BODY>
</HTML>
```

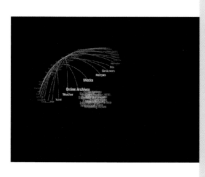

DESCRIPTION

PROJECT: MEDUSA
ACADEMIC WORK: THESIS PROJECT
DATE: 2000
DESIGN AND PROGRAMMING:
STEFAN BRANDY, COLIN HUGHES,
CHRISTIAN POLLAK
TECHNOLOGY: DIRECTOR SHOCKWAVE
FORMAT: PROTOTYPE OPEN-SOURCE
CLIENT-SIDE JAVA APPLICATION
WEBSITE URL: WWW.CHRISPOLLAK.COM

CONCEPT

Gathering and managing information in virtual environments will soon become a key task in our daily life, but, for users and the editorial staff of search engines alike, the categorisation and examination of the wealth of information on the internet is barely manageable.

Medusa is an experimental community platform that attempts to address this problem. Every user shares their experience of information sources with the community by adding personal link lists to the Medusa network. Each individual benefits from the community knowledge exchange. The interface visualises the structure of the internet defined by the community; the spatial navigation creating an interdisciplinary and orientational knowledge.

Designed to establish new techniques for improving the management of networked information for the user, the Medusa interface builds dynamic, interactive landscapes by translating the directory structure into more human and understandable codes.

GO TO >>> 68

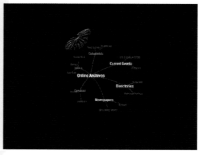

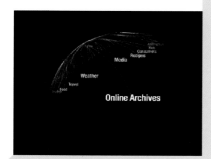

Steering away from the flatness of the computer screen, Medusa reveals the hidden depths of virtual space by evoking liquidity, architecture and imaginary environments.

As the user navigates through the site, there is an impression of the motion and stillness of a jellyfish. Words can be pulled out and dragged around the screen, strands of personal interests and information float and hang in space. Medusa gives a sense of what a community could look like and how content can be managed and displayed for free use. The freedom built into this system allows the user to manipulate and build their own virtual community, making this a very engaging and dynamic tool for visualising content.

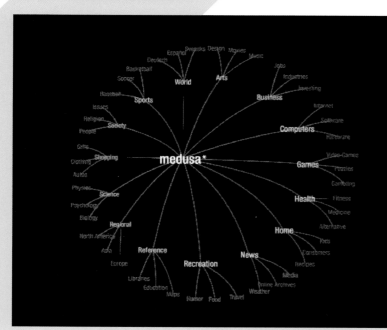

AFTER EFFECTS: AN APPLICATION FOR DESIGNERS AND FILM-MAKERS TO CREATE FILMS
USING THE SAME PRINCIPLES AS PHOTOSHOP - LAYERING, FILTERS, ETC.

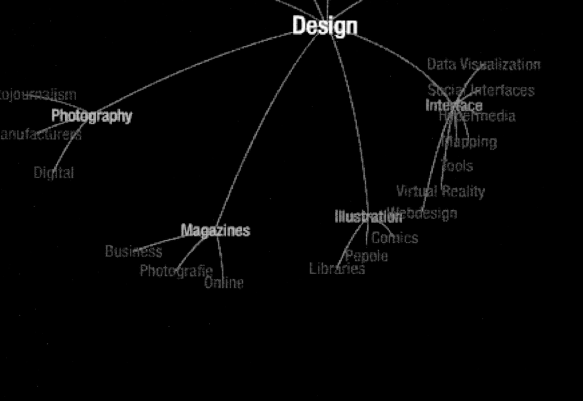

WWW.CHRISPOLLAK.COM

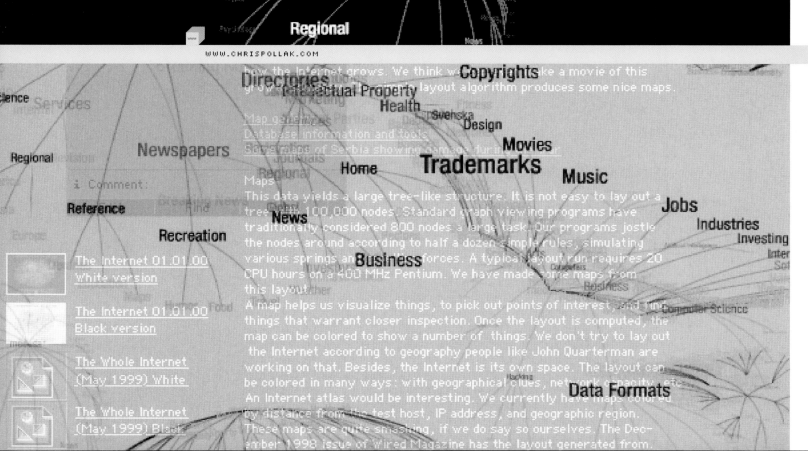

DESCRIPTION

PROJECT: WORKNET
ACADEMIC WORK: THESIS PROJECT
DATE: 2000
DESIGN AND PROGRAMMING:
STEFAN BRANDY AND COLIN HUGHES
TECHNOLOGY: DIRECTOR MOVIE
FORMAT: PROTOTYPE NEWSGROUP
BROWSER FOR CLIENT-SIDE JAVA
APPLICATION

CONCEPT

From global enterprises to local interest groups, a shared aim is using network technology for gathering knowledge and achieving common goals. The members of electronic communities often work at great distances from each other, resulting in the need for efficient communication tools. These tools should enable the users to exchange knowledge easily, discuss topics, draw conclusions and make decisions. Communicating via newsgroups is becoming increasingly relevant for the multifaceted, online society. Whether you need a tip on cooking tasty meals or technical advice on programming email servers, there are newsgroups for everyone on any topic at any time.

Worknet is available to members of electronic communities who share information over long distances. This model shows the flow of information that is available online: small clusters of users are visible (referenced as red), their user group identifiable by this mark. Like Medusa, this application is designed to visualise information and to give its online presence its own visible identity.

WORKNET
NEWSGROUP BROWSER

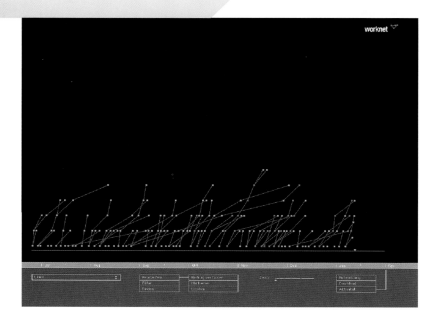

AIFF (AUDIO INTERCHANGE FILE FORMAT): STANDARD FILE FORMAT FOR DIGITAL AUDIO.

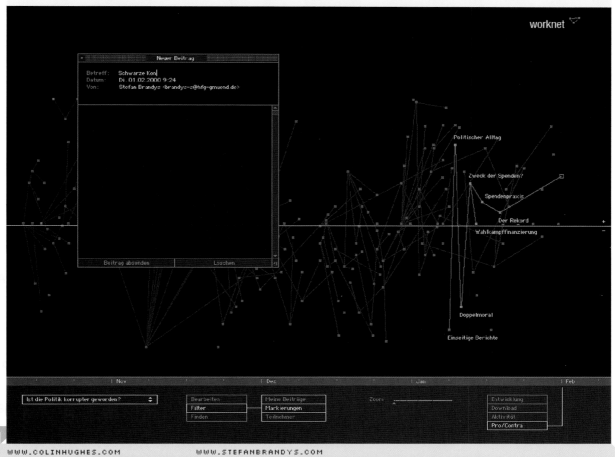

WWW.COLINHUGHES.COM WWW.STEFANBRANDYS.COM

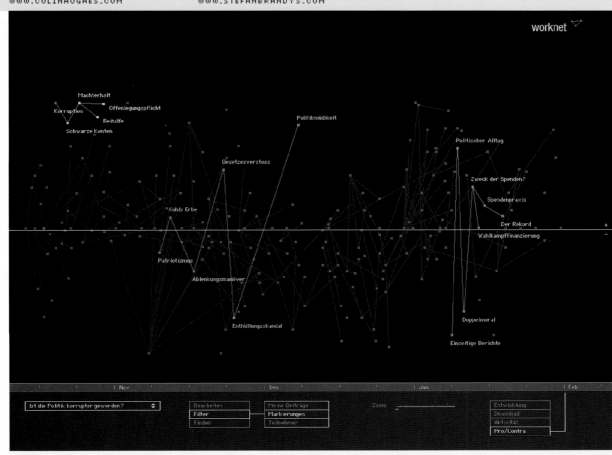

DESCRIPTION

PROJECT: RESONANCE OF FOUR
BRIEF: EXHIBITION PIECE
DATE: 1996
DESIGN AND PROGRAMMING:
TOSHIO IWAI
TECHNOLOGY: MIXED MEDIA
FORMAT: INSTALLATION
LOCATION: TOSHIO IWAI
RETROSPECTIVE (1996), GALLERY
OTSO, ESPOO, FINLAND. TOSHIO IWAI
INTERACTIVE (1995), THE
NETHERLANDS DESIGN INSTITUTE,
AMSTERDAM. VIDEO POSITIVE 95,
OPEN EYE GALLERY, LIVERPOOL, UK.
INTERACTION 95, IAMAS, OGAKI,
JAPAN. SERIOUS GAMES (1997) THE
LAING ART GALLERY, NEWCASTLE, UK.
SERIOUS GAMES (1997) THE
BARBICAN, LONDON, UK

CONCEPT

Resonance of Four is an interactive audio-visual installation that allows four people to create a musical composition in co-operation with each other. In this installation, four users are given different tones with which they can compose their own melodies. Each person uses a mouse to place dots on four grid images projected on to the floor.

Each player listens to the melodies that are being created by the other players, and then tries to change their own melody to make a better harmony. In this way, the installation will not only generate a resonance of sounds, but will create a resonance of minds between the four players.

When we view information on the internet, we might well be sharing the information with hundreds of other users.

The physical community of Toshio Iwai indicates the potential of virtual communities. The ability to engage with other users in a group is a growing online experience, and chatrooms such as www.habbohotel.com represent their community as a three-dimensional space, with users represented as pixel characters.

The accessibility of work made by Japanese artist Toshio Iwai is a perfect model of how people can interact with each other in a space. The dark space of the installation means that people can't really see each other, but they are able to build a graphic music score where each user can see what the next user is doing. This allows people to engage with one another through the creation of music – a creative community tool.

RESONANCE OF FOUR
INSTALLATION

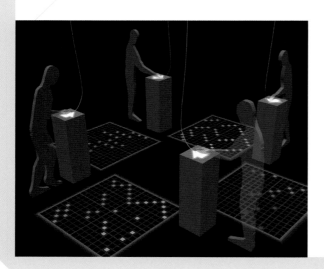

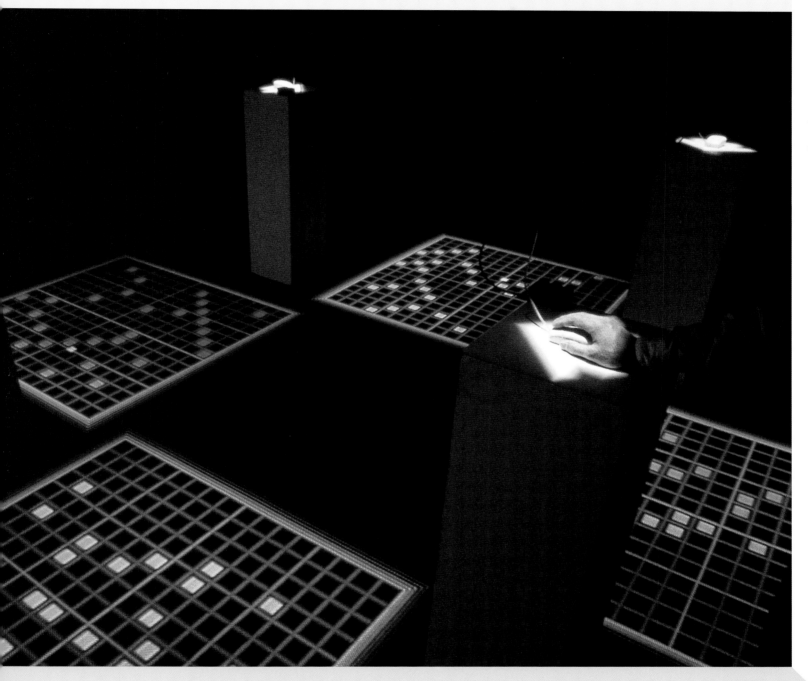

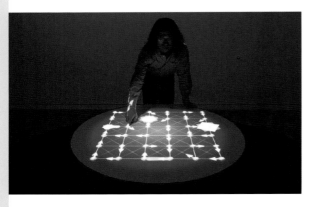

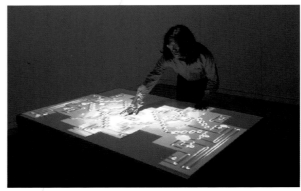

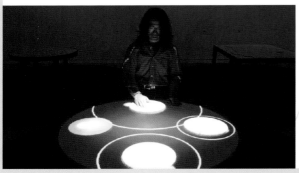

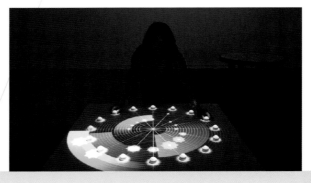

DESCRIPTION

PROJECT: COMPOSITION ON
THE TABLE
CLIENT: MIXED REALITY
SYSTEMS LABORATORY
DATE: 1999
DESIGN AND PROGRAMMING:
TOSHIO IWAI
TECHNOLOGY: INTERACTIVE SOUND
AND LIGHT SYSTEM
FORMAT: INSTALLATION

CONCEPT

This work allows the user to play with various
dynamic interfaces – dials, sliding boards,
switches and spinning tables – that any player
can touch, and which represent the concept of
a mixed reality. The images on the table are
projected from above the user, so that they
feel that the images physically respond to the
players' involvement. Sounds are also played
back via responsive movements to the system.

*At times we need to break away from viewing
work on the computer screen. Digital projectors
and portable computers allow us to project
information in a variety of spaces. In this work,
the standard keyboard is replaced by the use
of sensors that monitor the user's movements.*

BANDWIDTH: THE RANGE OF TRANSMISSION FREQUENCIES A NETWORK CAN USE.
THE GREATER THE BANDWIDTH, THE GREATER THE POWER AND THE FASTER DOWNLOADING CAN BE.

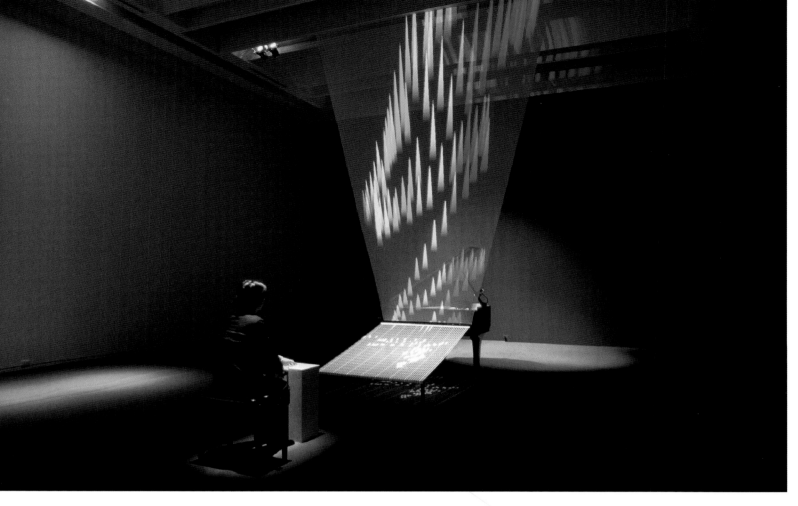

PIANO — AS IMAGE MEDIA
IMAGE AND MUSIC INTERACTION

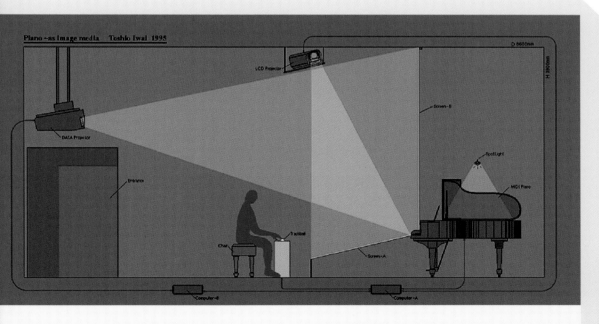

DESCRIPTION

PROJECT: PIANO — AS IMAGE MEDIA
CLIENT: ZKM/THE INSTITUTE FOR
VISUAL MEDIA, KARLSRUHE, GERMANY
DATE: 1995
DESIGN AND PROGRAMMING:
TOSHIO IWAI
TECHNOLOGY: MIXED MEDIA
FORMAT: INSTALLATION
LOCATION: MULTIMEDIALE (1995),
ZKM, KARLSRUHE, GERMANY.
INTERACTION 95, IAMAS, OIGAKI,
JAPAN. LA BIENNALE DE LYON
(1996), LYON CONTEMPORARY ART
MUSEUM, LYON, FRANCE. MEDIASCAPE
(1996), THE GUGGENHEIM MUSEUM,
NEW YORK, US.

CONCEPT

A flow of images is triggered by the user's
trackball and button to position and place
'dots' on a moving grid on the lower projection
screen. These dots constitute a virtual score
that triggers the piano keys, which in turn
project computer-generated images on the
upper screen. The patterns created with these
dots generate simple melodies and related
visual formations.

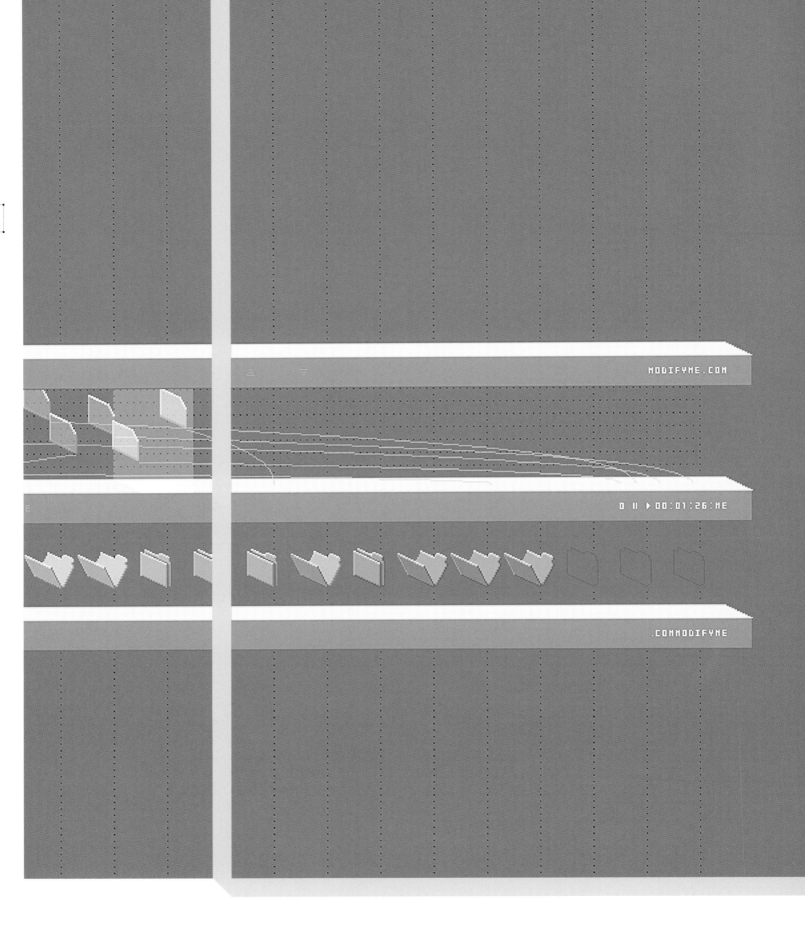

MODIFYME.COM

0 II ▶ 00:01:26:ME

.COMMODIFYME

WWW.MODIFYME.ORG

Engaging the internet user in play rather than waiting passively for a site to load is often neglected. This sound piece by James Tindall is an interesting development in streaming audio data seamlessly. The stream causes the user to forget that they are waiting for anything at all, although every few seconds another folder appears and more options become available. The online presence of this work is designed to transfix the user – they become so absorbed by the work they lose track of time spent waiting for the actual site to download.

DESCRIPTION

PROJECT: 'ARE YOU CONTENT?'
CLIENT: SELF-INITIATED
DATE: 2000
DESIGN, PROGRAMMING AND SOUND:
JAMES TINDALL
TECHNOLOGY: FLASH
FORMAT: WEBSITE

CONCEPT

Sound and image interaction.

'ARE YOU CONTENT?'
STREAMING MUSIC TOOL

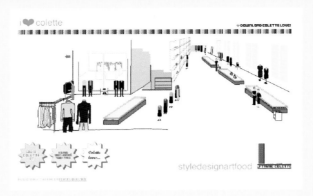

DESCRIPTION

PROJECT: ILOVECOLETTE.COM
CLIENT: COLETTE DEPARTMENT STORE
DATE: 2000
DESIGN AND PROGRAMMING:
FLIPFLOPFLYIN
TECHNOLOGY: HTML, ANIMATED GIFS
FORMAT: WEBSITE

CONCEPT

The website is described by the Colette store
as a place where fashion, design, art,
photography and music, as well as new
technological breakthroughs, can interact. 'An
atmosphere which astonishes us and reminds
us of our own identity; a sober, ever-changing,
light-filled space.'

I LOVE COLETTE
ONLINE RETAIL

*The online presence of a shop's identity is
brought to life with this beautiful illustrated
microsite. Small pixellated characters browse
in the shopping space, and speech bubbles
appear and disappear to create an impression
of activity. The highly stylised version of the
online store successfully reflects the identity
of the real store.*

BIT: THE '1' OR '0' THAT MAKES UP DIGITAL INFORMATION. THE MORE BITS IN A DIGITAL IMAGE, THE HIGHER THE RESOLUTION.

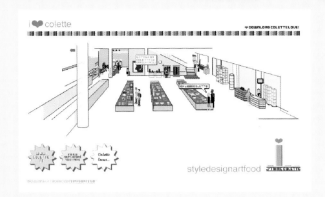

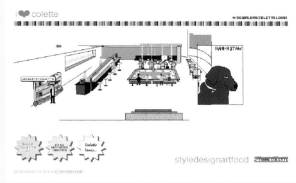

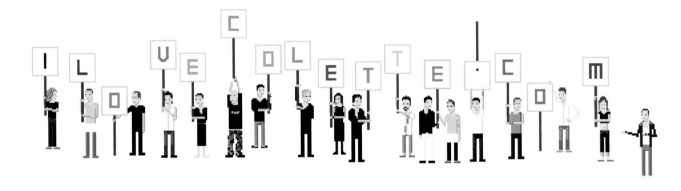

DESCRIPTION

PROJECT: FLIRT
BRIEF: RESEARCH PROJECT FOR
RCACRD
DATE: 2000
DESIGN: FIONA RABY
AND BEN HOOKER
TECHNOLOGY: HTML, ANIMATED GIFS
FORMAT: PROTOTYPE MOBILE PHONE

CONCEPT

FLIRT: Flexible Information and Recreation for mobile users was a European Commission research project under the 'IT for Mobility' theme. The development of digital cellular structures by the mobile communications industry has generated a genuine fusion between information space and urban territory. City location, the time, day and date can all begin to shape relationships to information sources. The tight constraints of mobile displays, juxtaposed with the spontaneity, unpredictability and transience of everyday mobility, requires a fresh approach to how this relationship might work.

FLIRT investigates the potential of location-specific information, not only as an information resource, but also as a medium for social interaction and play.

New media design is often very rich and dense, and advances in technology now allow us to choose to communicate through a varied palette of applications and devices. However, mobile phone displays rely on the designer to make full use of the small screen available – information needs to be designed and kept to a minimum. Due to the low-resolution screen, the designers worked directly with the pixel and designed a series of fonts that echoed the pixel format. Icons and symbols are alternative shortcuts to communication; here the designers have experimented using feline silhouettes and other graphics.

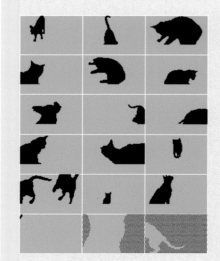

FLIRT
MOBILE NETWORKS

WWW

BITMAP: THE DIGITAL ARRANGEMENT OF DOTS THAT REPRESENT AN IMAGE.

NOW WASH YOUR HANDS
nowwashyourhands.com

FRONTPA
GEINFOR
MATION

NOWWASHYOURHANDS
UNITEDKINGDOM
NUMBEREIGHTEEN
ADVENT2001

ISSUE
ARCHIVE

NWYH
NEWS

12/3/2001 04:35:07 PM
Book publishers extraordinaire Die Gestalten Verlag have
'moved' – with a decent 3D anim to show you where. They're
also doing a new flyer book which we'll be contributing to
(sorry Tim, had to blow the whistle on that one!). Hmm while
I'm here check this out.
+++Dan Moore

12/3/2001 02:22:41 PM
BD4D Foundation SK8 Deck Design Competition 2002 at BD4D
+++Tim Spear

12/3/2001 12:21:58 PM
Tshirt design comp at DERUSH
+++Tim Spear

12/3/2001 12:21:00 PM
neue bits at Ai Records, from area info.
+++Tim Spear

NEWS
ARCHIVE

NWYHDESIGNCOMPANY

NWYHDOWNLOADS

NWYHSHOP

ABOUTNWYH CONTACT MAILINGLIST

LINKS [UK ▼] [music ▼] [worldwide ▼] NWYH IS PROUD TO PARTICIPATE AT
ARCHINECT
NEWSTODAY

NWYH
SUPPORTS

SK8 DECK DESIGN COMPETITION
BD4D+FOUNDATION

NOWWASHYOURHANDS
DESIGN STUDIO

WWW.NOWWASHYOURHANDS.COM

DESCRIPTION

PROJECT:
NOWWASHYOURHANDSUNITEDKINGDOM
CLIENT: COMPANY WEBSITE
DATE: 1999-PRESENT
DESIGN AND PROGRAMMING:
TIM SPEAR
TECHNOLOGY: HTML, FLASH
FORMAT: WEBSITE

CONCEPT

NOWWASHYOURHANDSUNITEDKINGDOM
is a UK-centric site relating to design and
music. New editions appear at irregular
intervals, designed either by NWYH officials
or in collaboration with other design groups.
Each number comes as a complete 'pack',
with screensavers and desktop wallpaper
to download.

*Companies market themselves on the web in
various formats. Here, NOWWASHYOURHANDS
promote their design ethos across three areas:
a design company, a download area and an
online shop – you can download the artwork
created, buy the t-shirt and browse the design.
They also invite guest artists to produce work
at irregular dates. This site relies heavily on a
strong illustrative identity that makes it
stand out from the crowd. It is humorous and
fun to visit.*

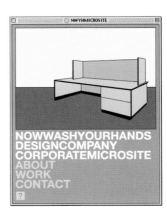

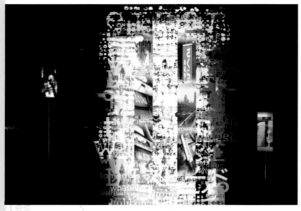

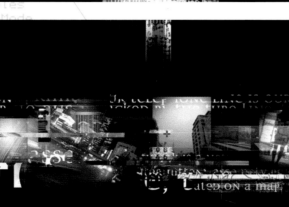

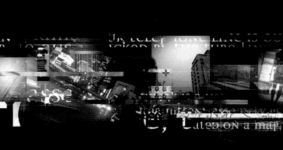

```
global gBu     les
global gA     Mode

on mouseDo
  global
  run gTe
end mouse

on mouseU
  castlis
["sungirl
["sungirl-

  n = cou
  nx = ra
  alist =
  deletea    astlist, nx)
  n = cou    castlist)
  nx = ra     m(n)
  blist =     plicate(cast
  deletea     astlist, nx)

  setCast    ubbles[1], al
  setCast    ubbles[2], al
  setCast    ubbles[3], al
  setCast    ubbles[4], al
  setCast    ubbles[5], al
  setCast    ubbles[6], bl
  setCast    ubbles[7], bl
  setCast    ubbles[8], blist[3]
  setCast    ubbles[9], blist[4]
  setCast    ubbles[10], blist[5]

  gAnimMod    = #randomize

  sound p     file 3, the moviepath & "sounds" & getDelim() & "mp13.aif"
end

on doScroll
  scroll the spritenum of me
end

on mouseEnter me
  cursor 280
end mouseenter

on mouseleave me
  cursor[11, 12]
end mouseleave
```

CONCEPT

Urban Feedback, London Tokyo was funded by Too Corporation as part of their yearly event called Graphic Arts Message (GAM). Tokyo Nomad is an interactive media experience that captures and conveys a sense of Tokyo through the relationship between time-based media and the subtleties of interaction.

London Tokyo is inspired by the chaotic energy of the two cities. Fragments of media ranging from street sounds to texts and films are fused together forming a dynamic reactive collage. The abstract, atmospheric theme of the work is based on impressions of Tokyo from the distant perspective of London.

DESCRIPTION

PROJECT: URBAN FEEDBACK, LONDON TOKYO
CLIENT: TOO CORPORATION, JAPAN
DATE: 2001
DESIGN AND PROGRAMMING: GILES ROLLESTONE, JULIAN BAKER AND SOPHIE GREENFIELD
TECHNOLOGY: MACROMEDIA DIRECTOR
FORMAT: CD-ROM

This spatial interface documents a dialogue between Tokyo and London by taking physical experiences and replaying them back through interactive media. The atmosphere in this work provides an instant nostalgic impression of a place. The navigation is very loose in its appearance, mirroring how one might take a wrong turn or get lost in such a physical environment.

URBAN FEEDBACK, LONDON TOKYO
TIME-BASED MEDIA

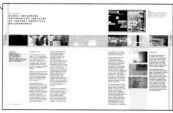

GO TO >>> 74

<DESIGN> PORTAL: THE FIRST PAGE VIEWED BY THE USER ON ENTERING A WEBSITE CONTAINING A CATALOGUE OF LINKS TO OTHER WEBSITES. A DESIGN PORTAL OFFERS THESE LINKS IN A VISUALLY ACCESSIBLE WAY.

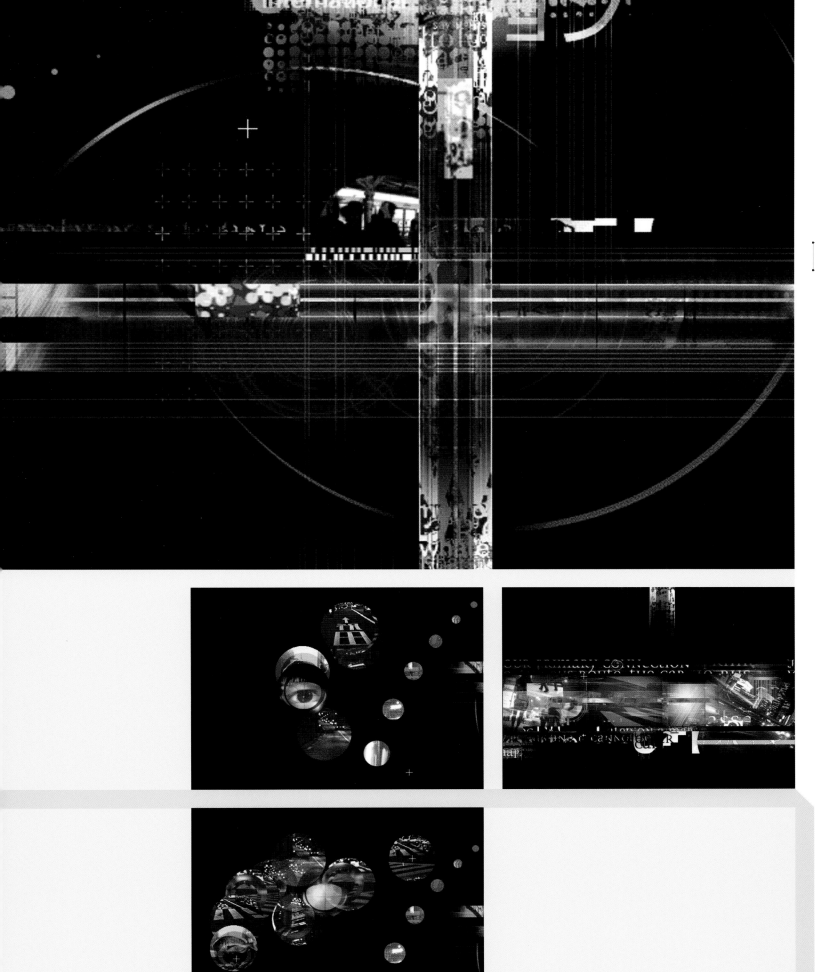

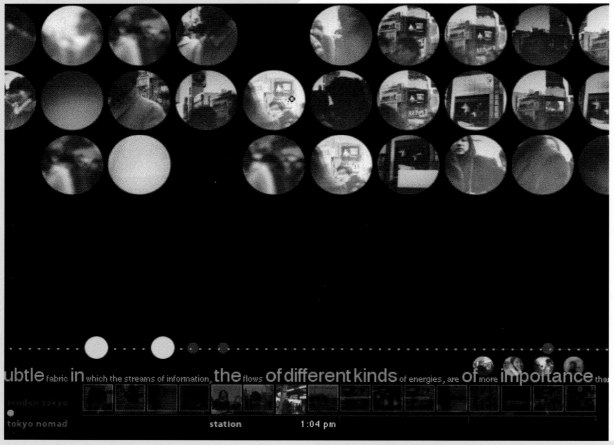

subtle fabric in which the streams of information, the flows of different kinds of energies, are of more importance tha

london tokyo

tokyo nomad station 1:04 pm

DIRECTOR (APPLICATION): DEVELOPED BY MACROMEDIA AND DESIGNED ORIGINALLY TO PRODUCE ANIMATION THROUGH BASIC PROGRAMMING,
DIRECTOR IS NOW, ALONGSIDE FLASH, A SOPHISTICATED APPLICATION AND A VERY POWERFUL STANDARD IN INTERACTIVE WEB MEDIA. IT ALLOWS
SOUND, IMAGES, QUICKTIME MOVIES AND OTHER MEDIA TO TALK TO EACH OTHER TO CREATE DYNAMIC WORK. DIRECTOR WORKS ON CD-ROM AND
INTERNET PLATFORMS. DIRECTOR MOVIE IS A STAND-ALONE FILE CREATED IN DIRECTOR AND FORMS A PERCENTAGE OF CD-ROM PRODUCTION (ALSO
KNOWN AS A PROJECTOR).

DESCRIPTION

PROJECT: URBAN FEEDBACK,
TOKYO NOMAD
CLIENT: DIGITALOGUE CO. LTD,
JAPAN
DATE: 2001
DESIGN AND PROGRAMMING:
GILES ROLLESTONE WITH
JULIAN BAKER
TECHNOLOGY: DIRECTOR MOVIE
FORMAT: CD-ROM

CONCEPT

Urban Feedback, Tokyo Nomad reveals events
and visual experiences over time – mapping
the real time of the computer clock to the
experience of Tokyo as an abstract, imagined
place. The 'time-based' device contains 16
different events, shifting and revealing in
response to the phases: Morning, Afternoon,
Evening and Night. Within each of the phases
are four interactive themes: No Address,
Without Words, Station and Balance. The
events are layered, eroding over time to reveal
glimpses and reflections of the visual
complexity of Tokyo.

*This work uses the computer's clock to
generate its interactive system: work
made in this space is akin to a screensaver.
Once installed, the software plays back
footage and scenes from a visit to Tokyo,
using the internal clock of the computer to
select appropriate images and video footage
of day and night scenes from the same time
in Tokyo. Taking ideas from installations
and art spaces, Tokyo Nomad's ambient
interaction opens up a whole new space
for designers and users to engage with.*

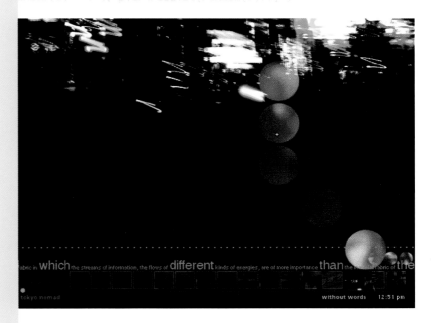

fabric in which the streams of information, the flows of different kinds of energies, are of more importance than the ... fabric of the

tokyo nomad without words 12:51 pm

EYES ONLY
HYBRID MEDIA

The user is able to navigate across a number of daytime and nighttime locations, scattered around the world. Atmospheric phenomena (rain, clouds, etc) appear unexpectedly as the locations are viewed. In addition to this, a set of unexpected 'events' may be triggered. These phenomena appear as judders, sudden flashes, and strange disturbances – all potential UFO sightings.

The minimal intervention of these phenomena mirrors the almost futile exercise of watching and waiting for UFOs. When a user sights a UFO they will be able to report the sighting by taking a snapshot and uploading it, for other users to see, to www.lessrain.com/eyesonly.

This CD-ROM/website by Less Rain makes interaction design simple and engaging. Its relaxing and dynamic nature makes it feel both seamless and timeless.

DESCRIPTION

PROJECT: EYES ONLY
CLIENT: SELF-INITIATED
DATE: 2001
DESIGN: LARS EBERLE, CARSTEN SCHNEIDER, ANDREA FEIGL
PROGRAMMING: VASSILIOS ALEXIOU, LUIS ALBERTO, MARTINEZ RIANCHO, PAUL HOPTON, CHRISTOS FRAGKOS
VIDEO: PHILLIPOS ARVANITAKIS, STEFAN GEORGI
PRODUCTION: LESS RAIN AND JOHN HOLDEN
TECHNOLOGY: DIRECTOR SHOCKWAVE, FLASH, AFTEREFFECTS, PREMIERE, HTML, ASP, MYSQL
FORMAT: CD-ROM/WEBSITE (HYBRID)

DONE

DRAW

OAD DISCARD

WWW.LESSRAIN.COM/EYESONLY

DIRECTOR SHOCKWAVE (INTERNET): SHOCKWAVE IS DIRECTOR MOVIE'S BROTHER FOR THE INTERNET. IT CAN CREATE TRULY IMMERSIVE, INTERACTIVE EXPERIENCES. DIRECTOR'S PROGRAMMING IS MORE POWERFUL THAN FLASH, SO IT IS USUALLY USED ON THE INTERNET FOR HIGHLY SOPHISTICATED USER EXPERIENCES.

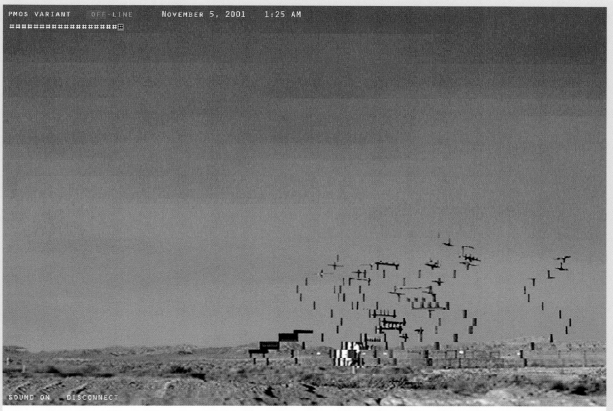

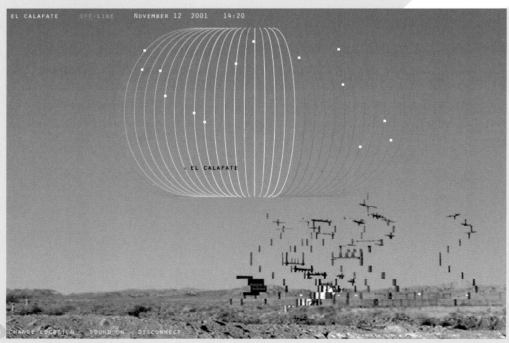

WWW.LESSRAIN.COM/EYESONLY

EMAIL (ELECTRONIC MAIL): MESSAGES SENT AS TEXT OR IMAGES THROUGH A NORMAL PHONE LINE VIA A COMPUTER NETWORK.

ERTAI ON-LINE NOVEMBER 12 2001 14:25

CHANGE LOCATION SOUND ON DISCONNECT

RTAI OFF-LIN NOVEMBER 12 2001 14:25

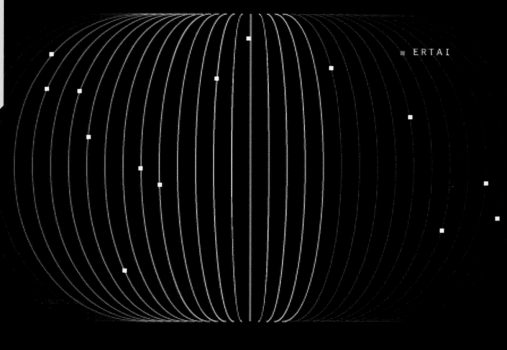

■ ERTAI

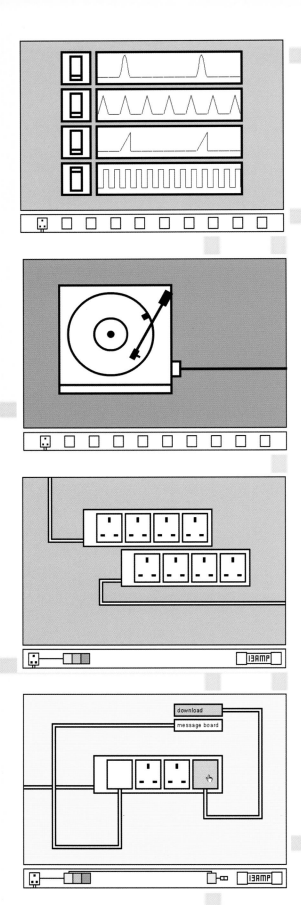

13AMP

13AMP

WWW.13AMP.TV

ENHANCED CD-ROM (DATA/AUDIO):
AN ENHANCED CD-ROM FORMAT COMBINES DATA AND AUDIO FILES THAT CAN BE ACCESSED FROM THE SAME CD. THE CD CAN BE PLAYED FROM A
STANDARD CD PLAYER AND THEN LOADED ON TO A COMPUTER TO VIEW VIDEOS AND MORE INFORMATION.

13 AMP RECORDS
MUSIC WEBSITE

DESCRIPTION

PROJECT: 13 AMP
CLIENT: 13 AMP RECORDS
DATE: 2001 (ONGOING PROJECT)
DESIGN AND PROGRAMMING:
FRIENDCHIP
TECHNOLOGY: FLASH, HTML
FORMAT: WEBSITE

CONCEPT

13 Amp was originally conceived to build
interest in a new record label. Design company
Friendchip (Antony Burrill's collaboration with
Kip Parker) was commissioned to build a
site without a client brief.

As the label didn't plan to release any
records for a while, the only experience
people would have of 13 Amp would be the
site – there wasn't yet any music from
bands signed to the label. It was left to
Friendchip to build the identity of 13 Amp.

*A series of interactive sound games enable
the user to interact and play with this site.
While the site is still under construction,
these interactive 'entertainment' elements
help the user become more than just a
viewer, hopefully enticing the user to come
back to the site once it is completed.*

GO TO >>> 150-151

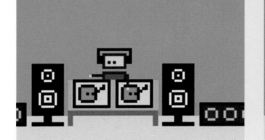

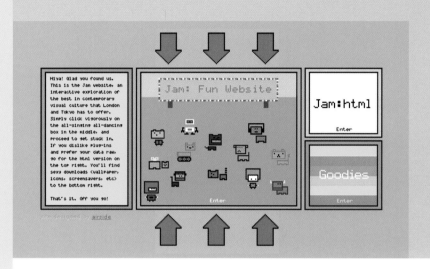

Hiya! Glad you found us.
This is the Jam website, an
interactive exploration of
the best in contemporary
visual culture that London
and Tokyo has to offer.
Simply click vigorously on
the all-singing all-dancing
box in the middle, and
proceed to get stuck in.
If you dislike plug-ins
and prefer your data raw,
go for the html version on
the top right. You'll find
sexy downloads (wallpaper,
icons, screensavers, etc)
to the bottom right.

That's it. Off you go!

site designed by airside

Jam: Fun Website

Enter

Jam:html

Enter

Goodies

Enter

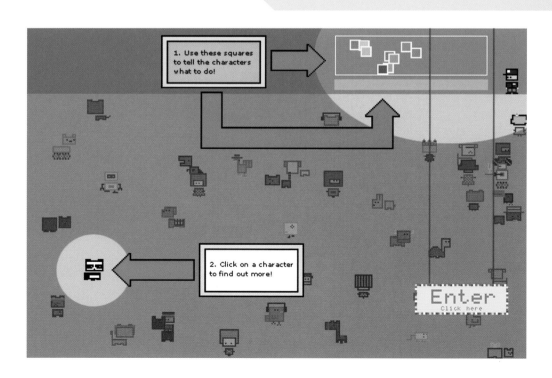

1. Use these squares to tell the characters what to do!

2. Click on a character to find out more!

Enter
Click here

FLASH: STANDARD WEB SOFTWARE FOR DESIGNERS AND PROGRAMMERS TO BUILD COMPLETE WEBSITES. FLASH HAS ALLOWED DESIGN TO FLOURISH, AS
THE APPLICATION IS BUILT SO THAT TYPOGRAPHY AND IMAGES CAN BE VIEWED AT HIGH SCREEN-BASED VECTOR RESOLUTIONS, RESULTING IN
CLEAN GRAPHICS AND RICH COLOUR PALETTES.

GO TO >>> 100

ONLINE JAM
PROMOTIONAL WEB TOOL

WWW.ONLINEJAM.CO.UK

DESCRIPTION

PROJECT: ONLINE JAM
CLIENT: BARBICAN GALLERY
DATE: 2001
DESIGN AND PROGRAMMING: AIRSIDE
TECHNOLOGY: HTML, SHOCKWAVE,
FLASH
FORMAT: WEBSITE, SHOCKWAVE
GAME, DOWNLOADABLE ICONS AND
DIGITAL WALLPAPER
WEBSITE URL: WWW.ONLINEJAM.CO.UK

CONCEPT

JAM: Tokyo London was an exhibition of contemporary urban design at the Barbican in the spring of 2001. Airside were asked to produce a website that would act not only as an online catalogue and promotional tool for the show, but also as a gallery exhibit to represent Airside's work.

On one hand, the website had to satisfy the needs of journalists needing to get fast and easy access to all the information about the exhibition, but on the other hand, the website had to be a piece worthy of inclusion in the show itself. The obvious solution was to call on the services of an army of animals, robots, princesses, a rabbit newscaster and a gerbil courier. All the elements that were used in the 'fun' site were reused in a much more direct HTML website, for direct access to the information: comparing the two is a fascinating illustration of the extremes of web design.

The images shown here are from the Shockwave version of the website; however, due to their pixellated nature, they don't change their appearance in the HTML version, just their interactivity.

Strong pixel character design and a fun gaming experience is a unique approach for showcasing contemporary culture in London and Tokyo. Illustrated characters remove the (often) tedious conveying of content – small characters run around the screen and it is the user's task to catch and click them to find out more information.

panda

kung fu bear

scooter boy

duck

classic robot

cat with hat

boy in a bear suit

robotic dog

crazy bird

GO TO >>> 92

A HYBRID SPACE

52

GO TO >>> 112

WWW.CALENDAR52.CO.UK

13
August
Monday

13

00
August
Phew!

FONT: THE DESCRIPTION OF THE SIZE, WEIGHT AND SPACING OF A CHARACTER. IN TYPOGRAPHY WE HAVE FONTS AND TYPEFACES. THESE ARE DIFFERENT – THE FONT IS A CHARACTER'S FORMAT, FOR EXAMPLE, 'TIMES 24-POINT ITALIC'; AND THE TYPEFACE DESCRIBES THE STYLE, FOR EXAMPLE, 'TIMES'.

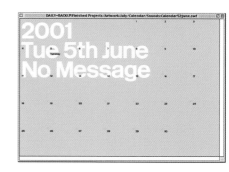

DESCRIPTION

PROJECT: CALENDAR 52
CLIENT: SELF-INITIATED PUBLICITY
DATE: 2001
DESIGN AND PROGRAMMING:
PAUL FARRINGTON AND
NIMA FALATOORI
TECHNOLOGY: FLASH,
SHOCKWAVE, HTML
FORMAT: WEBSITE

CONCEPT

Calendar 52 is an online visual exploration that challenges the conventions of visualising calendar dates with the use of experimental typographic systems. Each edition uniquely illustrates the corresponding calendar month, by referencing specific events that the user can jot down in a personal diary. Initially the project ran from June 2001 to May 2002; the 12 monthly editions were then archived and published in book format as a limited edition.

Calendar 52 was conceived as an interactive calendar to allow fellow work colleagues and friends to post event notices each month, enabling a small electronic community to become aware of each other's activities. Each month the calendar is designed afresh to challenge the rigid, unchanging formats of electronic diaries, calendars and organisers, exploring new ways of representing information.

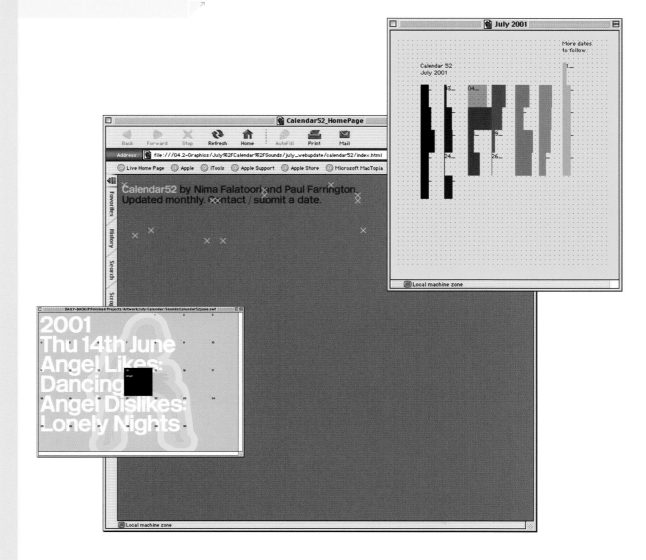

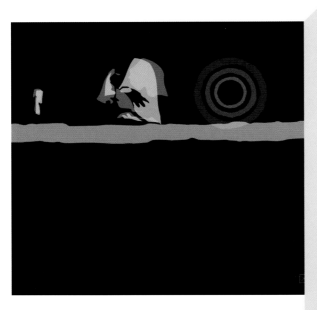

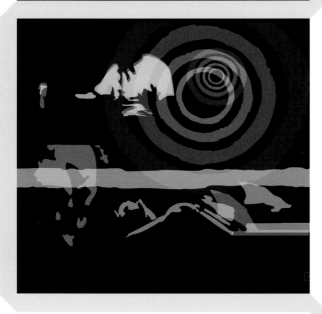

BBC DIGITAL AUDIO
BROADCAST STREAM

DESCRIPTION

PROJECT: BBC DIGITAL
AUDIO BROADCAST
CLIENT: BBC
DATE: 2000
CREDITS: AIRSIDE
TECHNOLOGY: FLASH
FORMAT: PROTOTYPE WEBSITE
(OFFLINE) AND DIGITAL RADIO
BROADCAST
WEBSITE URL: WWW.AIRSIDE.CO.UK

CONCEPT

The BBC asked Airside to create a prototype
digital radio broadcast to demonstrate the
potential of their new technology, using a
BBC Radio 3 Jazz performance as an
example. A digital radio broadcast can
contain data describing images, text,
animation or interaction alongside the audio;
this can then be displayed on screens
integrated into the latest digital radios, or on
a computer. The project began with almost
pure research, and went through a highly
creative development stage, ending with the
production of a new kind of radio show.
Coping with the extremely limited bandwidths
available, Airside innovatively defined a
completely new medium. While understanding
the way in which people would absorb the
broadcast; this is not television but not radio
either, begging the question – what is it?

Using the metaphor of an interactive
album sleeve, the designs represented and
augmented the music on a variety of levels.
The completed broadcast included 20 minutes
of ambient, abstract animations to accompany
the music that were produced in collaboration
with the artist Evan Parker, alongside an
interface showcasing samples of images
and text describing the performance.

*Digital radio allows more information than just
sound to be broadcast simultaneously – simple
and beautiful animations enhance the listener's
experience of digital radio. The sources for the
visuals come from videos of jazz players.
Designers Airside simplified the imagery and
adopted the vector qualities of Flash to allow
the film to stream continuously.*

GENERATIVE GAME: A GAME THAT PLAYS ON ITS OWN AND HAS BEEN PROGRAMMED TO BEHAVE IN ITS OWN MANNER WITH NO USER INPUT – YOU
COULD SAY THAT A GENERATIVE GAME IS SIMILAR TO A SCREENSAVER.

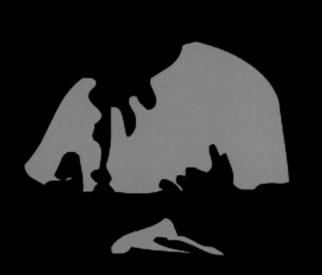

UTOPIA
GENERATIVE GAME

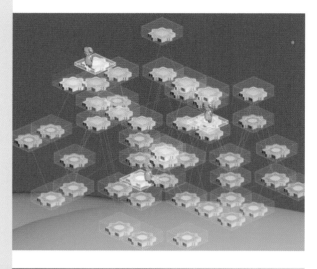

DESCRIPTION

PROJECT: UTOPIA
CLIENT: SELF-INITIATED
DATE: 2001
DESIGN: FUTUREFARMERS
PROGRAMMING: SASCHA MERG
TECHNOLOGY: DIRECTOR SHOCKWAVE
FORMAT: WEB MOVIE

CONCEPT

This piece is a Utopian vision of humanity,
projecting the shifting and blending levels
of consciousness, and continually presenting
the next step in the path. Utopia isn't
interactive – unless you consider films to be
interactive – it is more like a meditation.
Wherever the people walk, the ground comes
up to meet them. This is not a film, as it is
different every time.

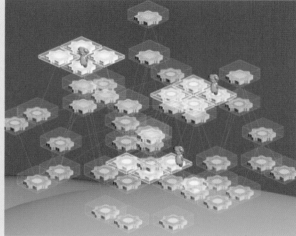

*Interactive forms that are similar to the
experience that is found in game design
are being created, allowing designers the
freedom to explore interactive narratives
and virtual spaces.*

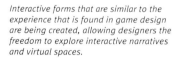

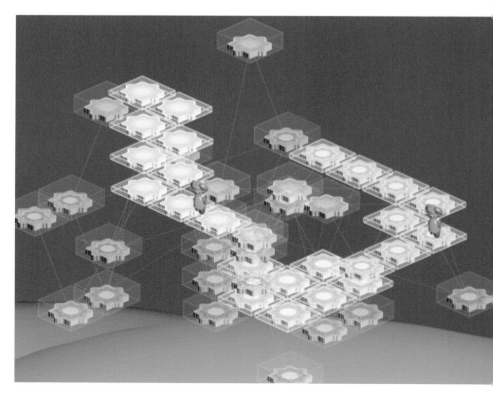

GIF <GRAPHIC INTERCHANGE FORMAT>: THE NAME OF THE IMAGE FILE THAT
IS THE COMMON FORMAT FOR IMAGES TO APPEAR ON THE WEB.

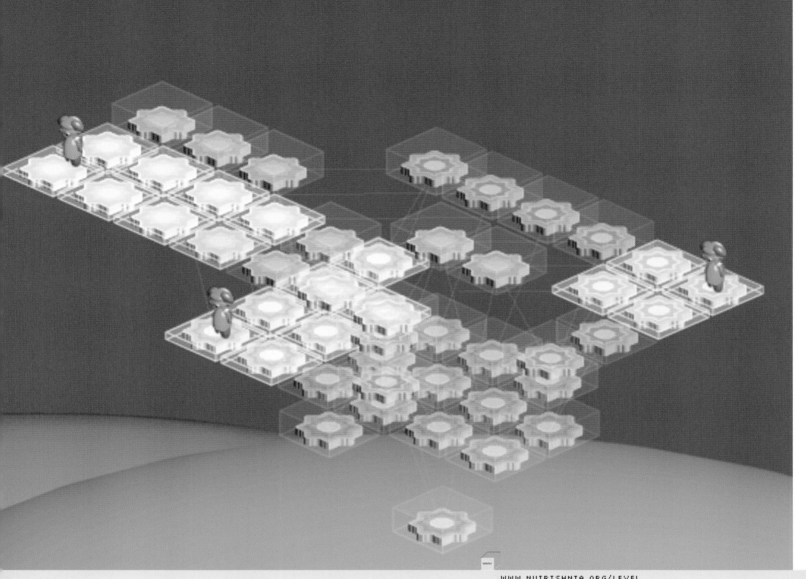

WWW.NUTRISHNIA.ORG/LEVEL

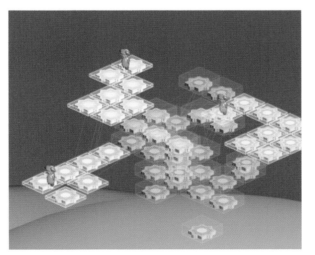

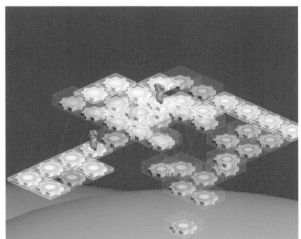

DESCRIPTION

PROJECT: THEY RULE
CLIENT: SELF-INITIATED
DATE: 2001
DESIGN: JOSH ON AND AMY
FRANCESCHINI
PROGRAMMING: JOSH ON
TECHNOLOGY: FLASH
FORMAT: WEBSITE

CONCEPT

They Rule aims to make some of the relationships of the élite of the US ruling class visible. It is a starting point for research about these powerful individuals and corporations. It allows users to browse through the interlocking directories of some of the most powerful American companies and easily run searches on them. If a user finds an interesting website about a company or director, they can add it to a list of URLs relevant to that company or director. A user can save a map of connections complete with their annotations for others to view. Future users can then show approval for URLs and maps by submitting a vote.

The ability to make users feel part of the online experience is demonstrated in this example. It allows you to create and construct your own community modelling map, demonstrating different ways in which users can access information and play with the forms in which it is output.

THEY RULE
ONLINE COMMUNITY

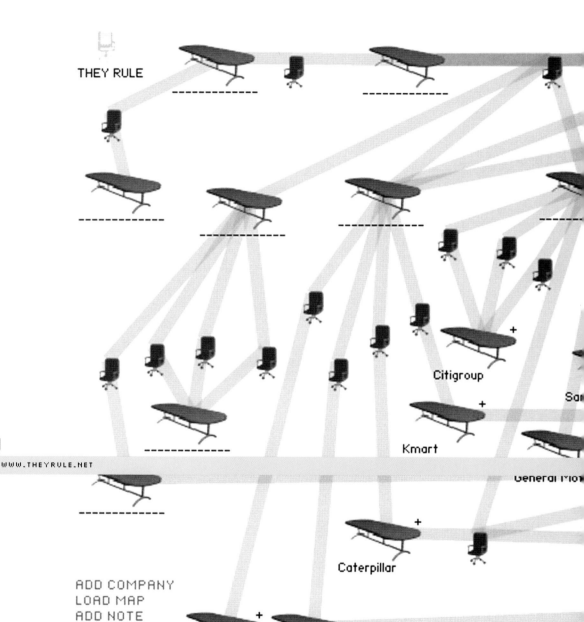

THEY RULE

WWW.THEYRULE.NET

Citigroup

Kmart

Sar

General Mot

Caterpillar

ADD COMPANY
LOAD MAP
ADD NOTE
SAVE MAP
CLEAR MAP
ABOUT
CREDITS

J.C. Penney

HEXADECIMAL: NUMBER SYSTEM BASED ON THE NUMBER 16 USED IN COMPUTER PROGRAMMING TO REPRESENT COLOURS ON THE WEB. LETTERS A-F ARE USED IN ADDITION TO NUMBERS 0-9.

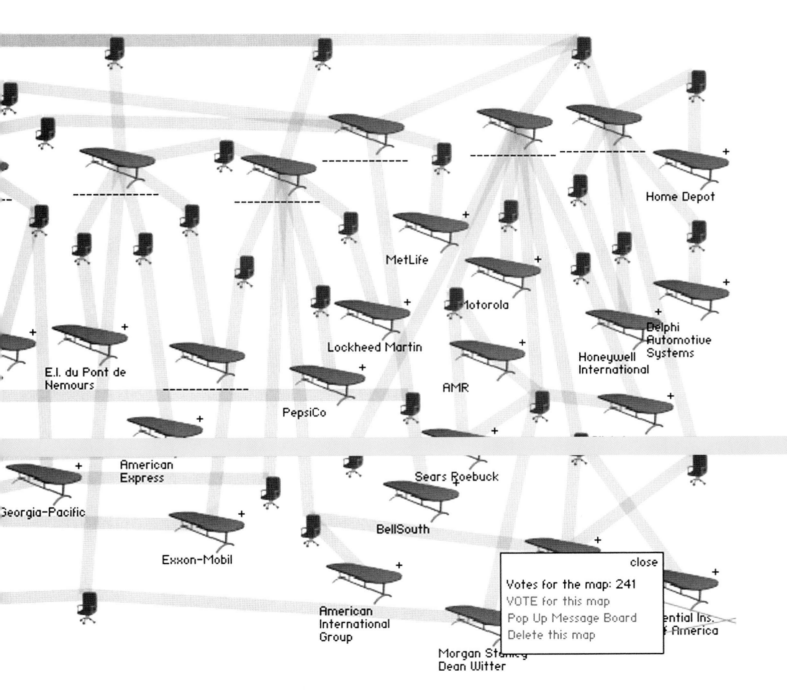

Home Depot

MetLife

Motorola

Delphi
Automotive
Systems

Lockheed Martin

Honeywell
International

AMR

E.I. du Pont de
Nemours

PepsiCo

American
Express

Sears Roebuck

Georgia-Pacific

Exxon-Mobil

BellSouth

American
International
Group

Morgan Stanley
Dean Witter

close

Votes for the map: 241
VOTE for this map
Pop Up Message Board
Delete this map

ential Ins.
f America

DESCRIPTION
PROJECT: SOUND TOY
CLIENT: LOVEBYTES
DATE: 2001
DESIGN: STUDIOTONNE
MUSIC: SCANNER
TECHNOLOGY: DIRECTOR
FORMAT: CD-ROM, WEBSITE

SOUND TOY
SOUND INTERACTION

GO TO >>> 92

CONCEPT

Sound toys are a series of graphic-led sound toy utilities that exist as CD-ROM applications and online. Interactions between sound and image developed throughout this work as art toys, games, interactive environments, utilities and soundbanks on a variety of platforms. These units of interaction create a variety of new relationships; between the creation of music and musical instruments, between the user and the music created, and between the music and its visual representation.

60

A HYBRID SPACE

Design and music have always worked well together – on the covers of record sleeves, for instance – and interactive media allows designers to take this collaboration a step further. Designers can now develop systems that allow internet users to interact with music and visuals, adding a new element not only to their own collaboration, but involving the audience too. The possibilities for users of such networked sound toys is far greater than the opportunities offered by just listening to the latest MP3 from their favourite musicians.

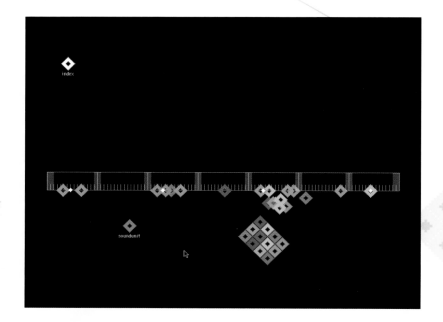

WWW.TONNE.ORG.UK

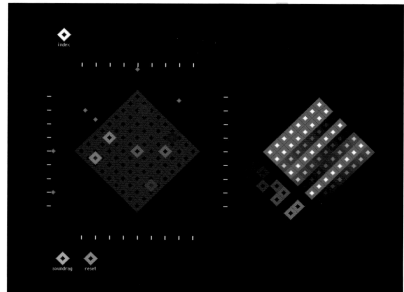

HTML (HYPERTEXT MARK-UP LANGUAGE): THIS LANGUAGE OF COMPUTER CODE DESCRIBES THE HYPERTEXT PAGES THAT ARE CREATED FOR USE ON THE WEB. HTML FILES ARE VIEWED THROUGH A WEB BROWSER, FOR EXAMPLE, INTERNET EXPLORER OR NETSCAPE.

DANNY BROWN VS LFO
INTERACTIVE WEB VIDEO

DESCRIPTION

PROJECT: DANNY BROWN VS LFO
CLIENT: WARP RECORDS/LFO
DATE: 2001
PRODUCTION: MARK BELL AND DANIEL
BROWN
TECHNOLOGY: DIRECTOR SHOCKWAVE
FORMAT: MICROSITE,
INTERACTIVE VIDEO

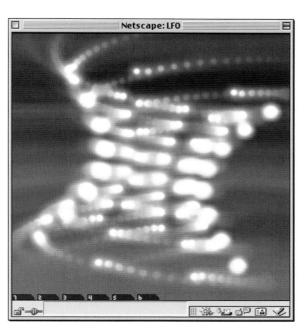

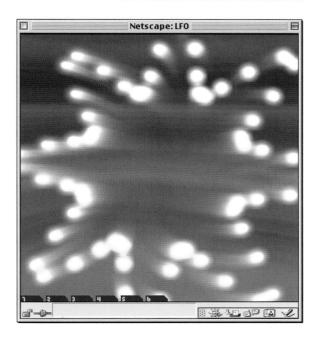

CONCEPT

Rather than create a web brochure advertising
musicians LFO, the concept was to create an
interactive piece in its own right, in a hybrid
genre of music, video and interactive media.
The piece was also used as a projection for an
LFO live event in 2001. The visuals are
smoothly streamed with audio, and the
glowing, revolving spots change direction
when clicked and dragged by the mouse.

Home		Shop New Objects	View Feature Article	Contact
Sign In/Account		Shop All Objects	View All Articles	Help
View Shopping Cart		Shop by Category	Company/Support	Privacy Policy + Term:

home/objects/all/detail

 View Cart/Checkout

62

A HYBRID SPACE

1 Select Size

A2 (25.2 x 35.4 in.)

2 Add to Cart

Price (US Dollars)
$24.00

Object Origin

Shipping Info
$4.48 for one ($1.50 each additional) via FedEx Ground from San Francisco, USA

Availability
Usually ships in 4 business days

Fehlermeldung, 1999
Cornel Windlin + Gilles Gavillet, Switzerland
Exhibition poster designed for the Museum fur Gestaltung, Zurich, Switzerland

w25.2 x h35.4 in., 2.30 oz., Paper. Smaller A2 format (see above specs).

"Error Design" sought to interpret the broken dreams of our dysfunctional and misbehaving products: why they don't function the way we WANT them to, and why they function the way we DON'T want them to.

Product usability studies from designers, safety regulators, consumer protection agencies and, of course, average Joes (and Janes), presented the exhibition-goer with multiple points of view, urging the viewer to conceptualize the problem of "error" from a phenomenological and systems-based perspective.

A chance to see the ways of our errors.

| Signed in from: 🇺🇸 | items | -- | Your Cart Is Empty |

WWW.DESIGNOBJECT.COM

designobject/winter 2001/

Home
Sign In / Account
View Shopping Cart

Shop New Objects
Shop All Objects
Shop by Category

View Feature Article
View All Articles
Company / Support

Contact
Help
Privacy Policy + Terms

▽ Shop Featured Object

home /objects /new /featured object
leave your gravity boots at the door.
born of both purist modern and sci-fi
kitch, the chill out room invokes perfect
geometric structure in the name of...

▽ Recent Additions

▣ Large Chill Out Room	▮▮ Fruit Bowl	▬ dwell magazine	▬ Light Up Pillow	Wall Graphic Calendar

▽ Featured Article (Requires Flash 5)
the there of theres

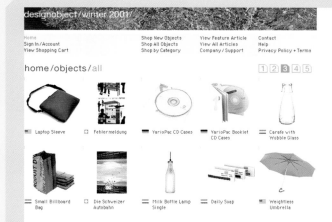

home /objects /all

1 2 3 4 5

▬ Laptop Sleeve	▢ Fehlermeldung	▬ VarioPac CD Cases	▬ VarioPac Booklet CD Cases	▬ Carafe with Wobble Glass
▬ Small Billboard Bag	▢ Die Schweizer Autobahn	▬ Milk Bottle Lamp Single	▬ Daily Soap	▬ Weightless Umbrella

DESCRIPTION

PROJECT: DESIGNOBJECT.COM
CLIENT: DESIGNOBJECT
DATE: ONGOING
SITE DESIGN/CONCEPT:
JOSHUA DISTLER
PRODUCTION: JOSHUA DISTLER
PROGRAMMING: BRAD BULGER,
WENDY COMPAGNO, JOSHUA DISTLER,
GYPSY ROGERS, JONATHAN SNYDER,
STEPHANIE SNYDER, LIZ WARNER,
BRIAN WOODRUFF
WRITING: AARON DISTLER, JOSHUA
DISTLER, STEPHANIE SNYDER
TECHNOLOGY: FREEBSD/UNIX SERVER,
POSTGRESQL DATABASE, PERL CGI,
HTML PAGES WITH FRAMES, FLASH
DYNAMIC, QUICKTIME FOR AUDIO,
ANIMATED GIF, VERISIGN/CYBERCASH
REGISTER FOR FREEBSD
FORMAT: WEBSITE

CONCEPT

designobject aims to use a retail shop
(and online shopping technologies such as
inventory management and region filtering) to
create a platform for independently produced
and distributed products and concepts.

*Internet shopping has opened up new vistas
of choice for consumers – creating a global
marketplace of enormous breadth and variety.
But it has remained dogged by problems with
site architecture and, especially, navigation.
This site is clear and concise in its delivery of
the objects for sale, with the design adopting
the look and feel of a glossy online magazine.*

DESIGN OBJECT
ONLINE RETAIL

DESIGN METHODOLOGIES

DESIGN METHODOLOGIES
FOUR WAYS TO APPROACH THE CREATIVE PROCESS

Through a series of essays by leading practitioners, this chapter takes a glimpse behind the scenes of internet design, revealing and exploring the designers' methodologies. These methods form the process of decision-making regarding the nature of the projects discussed. The essays discuss experimental concepts as well as work within a commercial setting.

Often, the structure of an internet site is invisible – the planning and process of organising the information embedded within it is covered in a layer of pixels and programming. The structure and design of the user's experience of the interface becomes the chief characteristic of the design process.

But it is becoming more and more important for designers to invest in a broader notion of what constitutes design: to devise ways and means of structuring their methods, their methodologies, of working. This is not to academicise or lay down stringent rules for design, but to seek a way to understand the processes of thinking that lead to true innovation – the harnessing of new ideas and their structured and useful implementation.

Designers of print media can often feel threatened by the internet and react by assuming that it is a world of bad design. But it is, in fact, a whole new tool for the graphic designer to handle. An easy route is to devise methods of production that are comparatively similar to the ways in which books are put together. Designers are used to dealing with a front cover and a contents page, but what happens when this information needs to be developed into a website? Is it enough for the same standards for print to simply be transferred over? No – designers need to look at other sources of how information is structured, from the plan of a building to travelling on the tube – navigational structures that deal with more than two dimensions. The website www.noodlebox.co.uk is a good example – where the design of a book has a standard contents page, the design of the navigation device found on this site uses an interface that you build yourself and play with. Foremost, it enhances the user's experience by allowing the control of the delivery of content, unlike the majority of sites where navigation tabs and images are fixed with no user involvement.

Governed by the non-physicality of networked spaces, the majority of internet sites use physical modes of navigation: buttons, menus and textures that exist in the material world are just copied and reformatted for use on the web. Designing simple navigation devices is a challenge for today's designers, so that the user works their way around as easily as possible. When designing for the internet, it is crucial that the user knows where they are, what pages they have accessed and how to get out and return to the main menu. Metaphors from the material world should not be taken for granted: it is all too easy for a user to become confused or lost when navigating through a site by intuitively expecting the virtual world to behave just like a material object (such as a book) might.

Navigation is an interesting environment to work in; in theory, every time a new site is designed, a new form of navigation is created from the content. In some ways designing for the internet is becoming more and more like designing architecture, transport systems or urban planning, as it is played out in the vastness of data space, but confined by the field of the screen.

The space used for screen design is often small – information has to be compressed for viewing text and images and to obtain optimum download times, etc. HTML typefaces at your disposal are very limited within HTML-based programs, whereas with Flash and Shockwave (Director) you can use all of the fonts within your system folder. Thinking about the most appropriate technologies to use is increasingly important for internet designers, as the emphasis shifts from pure websites to mobile phones, interactive television and other digital networked media.

Design practice isn't simply determined by software. The explosion of desktop publishing, high street design and print shops has enabled virtually anyone to take some words, scan in a picture and design a flyer, newsletter or company identity. In many ways, the internet is similar: software for designing web pages, even WAP sites, is freely available and can be mastered in next to no time. This do-it-yourself approach promotes self-expression and, in the right hands, has led to some socially and culturally significant work being made.

IT IS BECOMING IMPORTANT FOR
DESIGNERS TO INVEST IN A BROADER
NOTION OF WHAT CONSTITUTES
DESIGN: TO DEVISE WAYS AND MEANS
OF STRUCTURING THEIR METHODS,
THEIR METHODOLOGIES, OF WORKING.

The first essay, Building Medusa, by Christian Pollax, introduces the idea that a scientific approach can be taken to aid the creative design process. By examining the organic design systems that created Medusa, we witness a design process that grew out of research and the development of concepts of navigation. Pollax guides us through the project's important research studies and the design and development stages of Medusa that became important influences on one another.

Navigation isn't just about tabs and rows of vertical text – it can be made a sensory experience to be played with. Innovative, successful work is found by challenging the conventions that traditional print media offers and by looking toward the fluidity found in film, where language is constantly changing and forming new relationships between the viewer and the media. An example might be drawn from interactive television, where users are no longer simply consumers of pre-programmed shows, but can participate in the structuring and reception of content. For instance, a user watching a football match is now able to select which cameras to watch the match from by using their remote control.

The key is user experience, or experience design, and as such the design requires a more structured approach. Because of the many disciplines that go into making a website, designers are likely to find themselves part of a team and less like individual artisans. Collaborations between disciplines and areas of practice are going to become more common for the design and implementation of networked media – this may mean in the future that designers will become more like programmers, while programmers will become designers, or information architects. New languages will be needed to describe and communicate the many different kinds of content of clients' sites.

The second essay, by Giles Rollestone – Sushi: Networked Information Services in Context-sensitive Environments – describes conceptual design, development and implementation of software tools and digital media experiences through the development of a research project at the Royal College of Art. Traditional communication devices such as noticeboards, posters, diaries, calendars and word-of-mouth events inspired the Sushi interface. This work is an immediate interactive communication device that challenges the daily delivery of how network communications can be realised.

The third essay, written by creative programmer Gareth Langley of Stardotstar, discusses the positive and negative implications that may arise when programmers and designers work together. This partnership is coming to be a key relationship in internet design: there is a sense that, in the rush to incorporate all the latest web plug-ins, internet design can find itself hostage to the swift advances of technology, thereby hindering its role of communicator. Print design tends towards a clarity of information delivery – words on a page are designed to be read easily, or are intended to be visually arresting, jumping out and catching someone's attention. The multimedia possibilities of the internet often lead inexperienced designers into the trap of information overload – or the construction of complicated sites that require the user to download special software to view non-essential information. Where designers and programmers work in partnership there is a greater sense of how this can be managed more effectively – to be technologically innovative without losing the clarity of good design.

The final essay explores research and play. This area is the thinkspace where designers, programmers, technologists, etc, develop scenarios. Research and development work is allowed to cross over and inform commercial web platforms, and this helps push the boundaries of what the internet could be in the future.

All in all, these essays display the multiplicity of methods at designers' disposal – not that there is a right or wrong approach, only the gut feeling when it feels right. Ultimately, the test of success is whether the user goes back again and again.

CHRISTIAN POLLAK

BUILDING MEDUSA: A SCIENTIFIC APPROACH TO A CREATIVE PROCESS IN DESIGN

DESCRIPTION

PROJECT: MEDUSA
ACADEMIC WORK: THESIS PROJECT
DATE: 2000
DESIGN AND PROGRAMMING:
STEFAN BRANDY, COLIN HUGHES,
CHRISTIAN POLLAK
TECHNOLOGY: DIRECTOR SHOCKWAVE
FORMAT: PROTOTYPE OPEN-SOURCE
CLIENT-SIDE JAVA APPLICATION
WEBSITE URL: WWW.CHRISPOLLAK.COM

<01-03>
MEDUSA: EXPERIMENTAL
WORK IN PROGRESS
Visualised 'landscapes' of links shown
at various magnifications.

INTRODUCTION

Christian Pollak's work is characterised by an integrated design methodology based on a process of critical reflections, conception and design. He designs intelligent solutions in the area of multimedia, virtuality, networking and interface design. From February to December 2001, he was employed as New Business Consultant for a small German software company specialising in media asset management. Combining his academic interest in innovative information structuring with his work experience in branding, Christian brought forward topics like corporate brand processing and brand resource management. The projects stretched from editorial systems to applications for interactive television and three-dimensional environments.

Christian's interest in information architecture has developed through his detailed work on the Medusa project, which took two years to develop. This culminated in his design thesis. Medusa shows methods of analysing, structuring and organising information and is an experimental model for dynamic and interactive data visualisation.

Medusa is an open-source application in that it allows the user to modify the software to fit their personal profile. Specifically, it provides a visual databasing structure from which to organise found information. The application grows in complexity as ever-larger amounts of information are collected.

01

02

03

INTERFACE: A SYSTEM THAT PROVIDES THE USER WITH INFORMATION IN VARIOUS FORMATS FROM WHICH THE USER SELECTS.
WE CAN ALSO INTERFACE WITH MEDIA AND BE IN PHYSICAL CONVERSATION WITH IT.

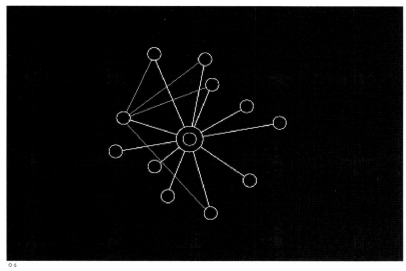

‹04–06›
MEDUSA: EXPERIMENTAL WORK IN PROGRESS
A link (inner circle) with its meta information (outer circle), and the predefined connections to
other websites (lines and small rings) and contexts of bookmark collections of different users (fan).

07

08

09

‹07–09›
MEDUSA: EXPERIMENTAL WORK IN PROGRESS
Investigating how to link differently visualised hierarchies.

MAPPING SPACE

Physical metaphors can support abstract processes of reasoning. Very often metaphors are taken too literally. In general, operational elements and metaphorical symbols fill the screen; this is a visual device to concentrate the attention by removing peripheral distractions. To enhance effective action, 100 per cent of the screen should be used for the representation of the relevant information.

For a better navigation and orientation in virtual spaces, the important metaphor to add to would be maps. For thousands of years, the creation and use of maps has been an established literacy. Using projection, abstraction and all sorts of symbolism, images are created to facilitate a selective perception. Maps are never realistic representations of the environment they depict. They are always designed for a specific objective.

Maps of cyberspace help us visualise and comprehend the new digital landscapes beyond our computer screen, in the wires of the global communications networks and vast online information resources. These cybermaps, like maps of the real world, are objects of aesthetic interest. Maps have a wonderful history – they can introduce whole new geographies. Mapping the network to discover these geographies is one important way of mining the information needed to create these new navigational aids.

In contrast to designing information graphics in high-resolution print media on non-restricted areas, the screen offers the challenge of a smaller area with lower resolution, but it also offers completely new parameters of visual representation. To get an overview on data, methods of abstraction and compression need to be used. The possibilities of dynamic, interactive, scalable and filterable representations are of great advantage when dealing with networks of information that are constantly changing, growing and moving.

10

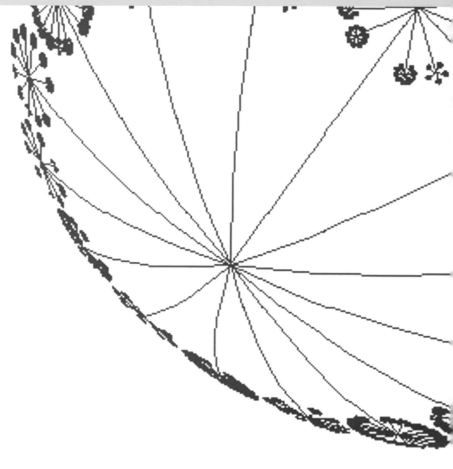

<10>
MEDUSA: VIRTUAL SKETCHES
Sketches of the Medusa structure visualised with a multiple fisheye.
The Medusa network is an open structure that has no limitations of
complexity. Very often there is the problem of representing large amounts
of data in a restricted space. Databases, organisational diagrams, texts
or maps in general are too big to be shown as a whole on a screen.
With the fisheye view, a big and open data structure can be shown.

INTERNET: A CONNECTION OF TWO OR MORE NETWORKS.

DEFINING THE PROBLEM

To achieve results that display a high degree of originality and innovation, the predefined topics need to be researched and realised. The design process starts with methodical processes that lead from recognition of the problem, through the analysis and co-ordination of specific information and knowledge bases to a definition of the problem.

A need has been found for new visualisation and interaction tools. The goal is an objective and interactive manipulable representation of data. Advanced navigation techniques and an improved orientation in software interfaces are the main steps to a better online communication. A static image pretending to represent the patterns of a community is misleading, for this pattern has no absolute form. Via dynamic representations, the user can immediately understand ongoing social activities.

Medusa concentrates on three central aspects of interactive design: the user, the technology and the interface.

ANALYSIS

LITERACY
The project should be seen as a contribution to the design of a new literacy, which enhances the possibilities of the internet. Gathering and managing information in virtual environments will be established as a main task of our daily life. The aim is to make it easier for the single user to deal with tasks that need to be managed digitally.

TOOL
The design of the tool moves from being static to having dynamic and interactive landscapes, which translate the complex webs of information and activities of the internet as an abstract space into a code that is more familiar and understandable for the user.

ACCESS
To make orientation and navigation easier, every single link needs to offer decision-making criteria to serve as access to the virtual information sources.

COLLECTIVE KNOWLEDGE
Each individual benefits from the community knowledge exchange. The worldwide network of individual users enhances the creation of communities of interest. These communities or groups of experts generate collective knowledge through their communication.

SOLUTION OF THE PROBLEM: THE VISUAL TRANSLATION
The analysis of the problem leads in turn to an experimental design process, which moves through several creative and evaluative phases before culminating in the realisation of the chosen design in a suitable model form, and before an assessment of the possible consequences. They demand extensive research, and the results display a high degree of originality and innovation.

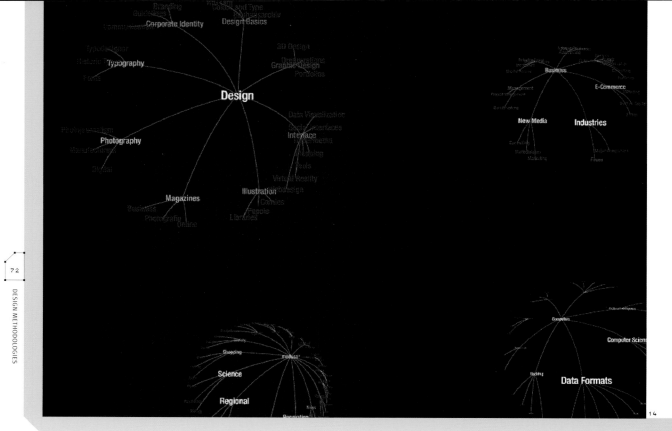

〈14–15〉

MEDUSA: USER NAVIGATION

By clicking on one of the lines, the sphere can be turned to navigate through the categories without interruption. A field of interest can be focused on without losing the overview. The attention is drawn to the focused area through the changing brightness and scale of the typography. By double clicking on one of the lines, the sphere can be positioned on the screen.

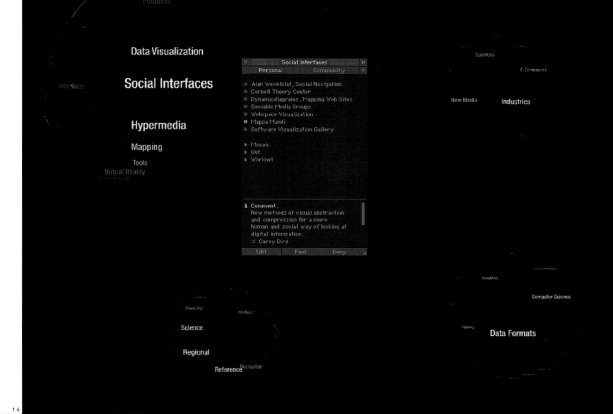

16

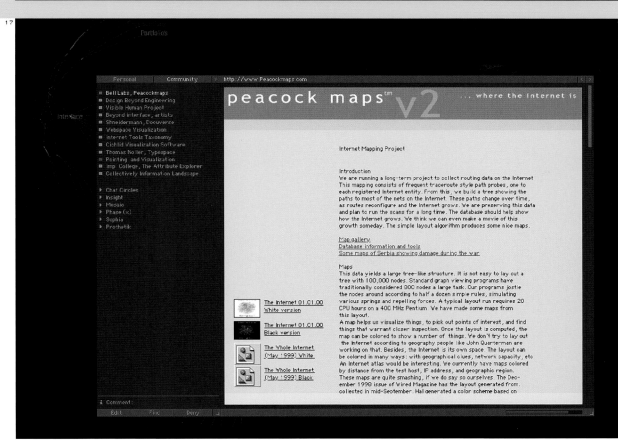

17

<(16-17)>

MEDUSA: USER NAVIGATION

By double clicking on a category, a link list opens up in a new window.
All information in the category is separated into personal links and a pool
of links that other editors of the same category have collected. Several features,
eg, a ranking of the link usage or an update notification, offer criteria of
decision and orientation that help to judge the information in the link list.

SUSHI: NETWORKED INFORMATION SERVICES IN CONTEXT-SENSITIVE ENVIRONMENTS

01

02

to explore concepts of place,

DESCRIPTION

PROJECT: SUSHI:
NETWORKED INFORMATION
SERVICES IN CONTEXT-SENSITIVE
ENVIRONMENTS
ACADEMIC WORK: SELF-INITIATED
DATE: 1997-2001
CONCEIVED BY: MARTIN LOCKER,
IAN MORRIS, GILES ROLLESTONE
DESIGN AND PROGRAMMING:
IAN MORRIS, GILES ROLLESTONE
FORMAT: INTRANET

IMAGINED CITIES

The city has become a recurrent metaphor in the conceptualisation of the internet, from the worldwide web to MUDs and MOOs (text-based internet games). The form and structure of the internet is like a stretching, organic city sprawl, creating cities within cities that are enormous, clumsy and extremely difficult to conceptualise, map or navigate.

Imagine a place you could go where accessing information was more like moving about a city, where browsing was more like wandering down a street. A place of fleeting imagery, fragments of conversations and chance encounters.

Virtual environments have historically tended to focus on the realm of the real visual world. Literal representations of rooms, buildings and streets are created rather than focusing on the sensory and experiential qualities of a particular environment or situation. Virtual environments with concrete, finite three-dimensional qualities alone cheat virtual and real space of its full potential, missing the opportunity of mixed interactions between people, objects and environments.

Historically, architecture was the social and cultural mediator of society's stories. Buildings – cathedrals, for example – were representations of power and knowledge; they were communication spaces in their own right. Now, postmodernist theory tells us that the medium is the message (McLuhan) and the world is simulacra (Baudrillard), ie, 'reality' is lost in the the overload of information. There are many more competing communication formats – sometimes buildings, sometimes magazines, billboards, sounds, fashions and shops – often temporary and ephemeral, sometimes tangible, sometimes intangible. Communication becomes a dynamic interplay of real space and virtual space whether this takes place on the streets, within our communication networks or in our heads.

The sushi 'belt' was developed as a reaction to these ideas. The sushi belt, which originated in Japan, carries food around a restaurant on a mini travelator (reminiscent of airport transport), allowing customers to select food at their leisure. In our fast-food city culture this gimmick has been adopted worldwide. The sushi belt is used

03 martin's strip - Strip

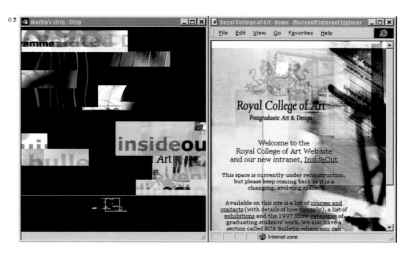

〈01–08〉
SUSHI: INITIAL VISUAL RESEARCH
Images of city-based modern life were collected in the project's initial stages, as were screengrabs of the college website and intranets. Images of haphazard noticeboards completed the investigation.

04 05

WWW.URBANFEEDBACK.COM

as a metaphor in this interactive project that explores our modern interpretations of information.

Network infrastructures such as the internet and wireless communications are radically changing many of our basic living patterns. We are moving toward an increasingly fluid way of communicating, working, playing, travelling and being, with greater mobility and personal freedom. Now when we make a telephone call, it is to a person, not a geographical location or place, which means that conversations – in fact interactions of any kind – can potentially take place anywhere. In this context, our simplified notions of location and place become relevant in new and perhaps unusual ways.

The internet has grown to become far more than an electronic bulletin board for people in the computer industry. It is a place to do research, to amuse oneself, to gather information and, increasingly, do business; to develop relationships and maintain connections. Networks have not only transformed the business models of organisations but are reshaping existing social landscapes, creating new social shapes affecting the forms and communication structures within these environments – inside and out.

06

07

08

INSPIRATION

The Sushi Project explores the very nature of the computing medium itself – how a system can be represented, how the system appears to people using it, ways people can interact with the system and what qualities it suggests.

Sushi was developed as a new way of sharing information between people in small groups and networks within the Royal College of Art. Based on the idea of a notice or bulletin board, the system extended its original use by exploring the possibilities of networked screens to represent relationships between public and private, and real and virtual, drawing on ideas of both montage and the narrative of the city. Sushi represents a small-scale community, and all the associated interactions that take place in such an interpersonal space.

<09-12>
SUSHI: INITIAL VISUAL RESEARCH
Experimental messages.

<13>
SUSHI: INITIAL VISUAL RESEARCH
Detail of the belt.

EARLY DEVELOPMENT

Sushi's look and feel evolved
from a desire to create a visual-
spatial environment that offered an
alternative to prevailing user
interface standards and conventions
prevalent in Macintosh/Windows
operating systems and applications.
Sushi is a visual-spatial environment
for creating, manipulating and
viewing information. Media and
information are represented as
themselves (non-iconic). Layered
images and interface elements
express the context and tasks that
need to be completed. Sushi fuses
the language and syntax of tools and
digital time-based media embedding
features and functionality within the
narrative space of the application.

USER-ORIENTATED RESEARCH

Based on the metaphor of a Sushi
bar conveyor belt, tiny images, text
or animated icons are pushed along
a virtual conveyor belt connecting
everyone working at their machine
at the same time. The icons are little
tasters of what lies behind them, for
example, links to internet-based
events, notices and websites.

The application includes a simple
authoring scenario in which people
can easily create their own notices
and icons, and link in their
own pages.

The result is a textured environment,
more akin to moving through a city,
where browsing is like wandering
down an street; a place of fleeting
imagery, fragments of conversations
and chance encounters.

PROTOTYPING

The Sushi research team looked at
the different scales in which people
live and communicate with one
another; the city, the club, the dinner
party and one-to-one conversations.
Searching for ways to characterise
communications scales in different
situations and media, the team's aim
was to create the framework and
infrastructure of a city. However, this
became too ambitious. The focus
shifted towards their primary target
audience in the Royal College of Art,
which fitted the social scale of a
club. The application, called 'The
Active Media Transit System',
focused on dinner party
conversations; the belt became the
output of a fictional kitchen and the
information exchange was the
conversation patterns situated
around a dinner party.

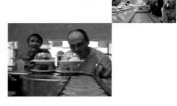

<14>
SUSHI: INITIAL VISUAL RESEARCH
Images of a sushi belt in a Japanese restaurant.

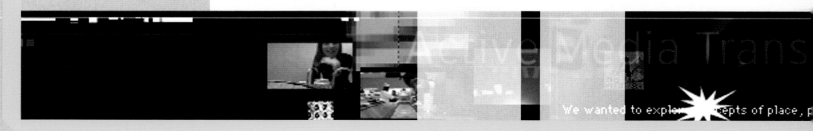

VISUAL LANGUAGE

The team spent time talking to both students and tutors, improving their understanding of the culture and the environment, the activities people were involved in, and their difficulties and desires. Noticeboards, adverts for services and specific events were integrated and located within the Royal College of Art. These notices were scattered in specific locations such as in lifts, corridors, the coffee bar and the walls of the canteen – places either passed through or spent transitory moments in, perhaps drinking coffee, eating a meal or talking to colleagues and friends. Notices in these in-between spaces took on an ambient presence. The random juxtaposition of different notices not only created multilayered information spaces, but also offered representations of short-term history and collective memory.

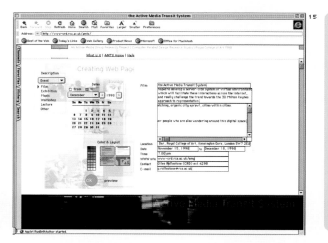

15

<15-16>
SUSHI: WORKING PROTOTYPES
The Sushi Belt is designed to travel across the screens of networked terminals. so that a constant flow of information can be viewed and accessed at any one time. If you see something passing that you like, you can click on it and it opens up on your desktop.

<15> This shows how the screen is split into two; at the top is the software that enables the user to design and create a message to be posted below on the Belt (black band).

<16> This page previews your designed message prior to publishing and posting on to the Belt.

16

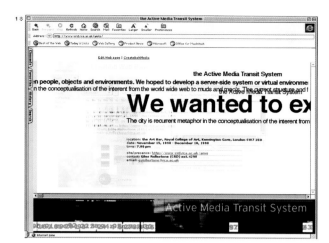

<(17)>
SUSHI: FINISHED DESIGN
Detail of Sushi Belt.

17

DEVELOPMENT

The following questions were asked:
What could the experience be like?
What are people's mental models for
this kind of thing?

Interfaces and navigation systems
generally offer perceived control
and access to everything and
anything at any given moment.
These environments have a
particular richness, but in some
instances do not afford accidental
encounters in the form we
experience in day-to-day lives
through chance collisions with other
people, places and situations. The
first release of the Active Media
Transit System needed to establish a
limited set of features and functions.
The team essentially wanted to see
how people inhabited the system
before applying specific features.
Features could be context- and
location-sensitive and so be built
into the application at a later stage.

Because of this simplicity, the
opportunity existed for potential
subversion, accidents, and different
uses of the environment in ways that
the team never imagined.

<(18-19)>
SUSHI: FINISHED DESIGN
Examples of messages that have been created with the software.

```
GLOBAL BLOB1, BLOB2

GLOBAL NUMBEROFCHILDREN

ON PREPAREMOVIE
  CLEARGLOBALS

  STAGEWIDTH = THE STAGERIGHT - THE STAGELEFT
  STAGEHEIGHT = THE STAGEBOTTOM - THE STAGETOP
```

GARETH LANGLEY

LINGO LAVALAMP:
CREATIVE PROGRAMMING

```
  SET ACTIVESTAGE = THE RECT OF SPRITE 120

  SET MAXHEAT = (THE WIDTH OF ACTIVESTAGE/2.0) + THE HEIGHT OF ACTIVESTAGE

  SET NUMBEROFBLOBS = RANDOM (3)

  SET MINNUMBEROFCHILDREN = 3

  REPEAT WITH I = 1 TO NUMBEROFBLOBS
    ADD THE ACTORLIST, NEW(SCRIPT"BLOB OBJECT")
  END REPEAT

  SET FROMCHANNEL = 11
  SET TOCHANNEL = FROMCHANNEL + MINNUMBEROFCHILDREN --- RANDOM(2)

  REPEAT WITH I IN THE ACTORLIST

    MAKECHILDREN I, FROMCHANNEL, TOCHANNEL

    SET FROMCHANNEL = TOCHANNEL + 1
    SET TOCHANNEL = FROMCHANNEL + MINNUMBEROFCHILDREN + RANDOM(2)

  END REPEAT

END

ON STOPMOVIE

    SET THE ACTORLIST = []
  END IF
END
```

GO TO >>> 108

```
ON GETTEMP LOC
```

DESCRIPTION
PROJECT: LINGO LAVALAMP
BRIEF: SELF-INITIATED
DATE: ONGOING
DESIGN AND PROGRAMMING:
GARETH LANGLEY
TECHNOLOGY: DIRECTOR SHOCKWAVE
FORMAT: WEBSITE

```
ON RANDPOS
  SET POS = POINT(RANDOM(THE WIDTH OF ACTIVESTAGE) + THE LEFT
ACTIVESTAGE, RANDOM(THE HEIGHT OF ACTIVESTAGE)
  RETURN POS

END

ON OPPOSITE X

  RETURN X - (2*X)

END

-------------------- BLOB OBJECT ---

PROPERTY CHILDREN, TEMP, MASS, HEADING, WIDTH, HEIGHT, BOUNCETOP,
BOUNCEBOTTOM, MODE
PROPERTY MYCHANNELS

GLOBAL STAGEHEIGHT, STAGEWIDTH, ACTIVE

ON NEW ME

  SET CHILDREN = []

  SET TEMP = 0

  SET MASS = 1000000.0

  SET WIDTH = THE WIDTH OF MEMBER
11 IS A CHILD
  SET HEIGHT = THE HEIGHT OF MEMBER

  SET BOUNCETOP = 0
```

LEARNING AND DEVELOPMENT

Beautiful multimedia is the symbiosis of creativity, design and technology. Unless your name is Danny Brown or John Maeda, you, like the rest of us, will probably fall into one of the two categories of designer or programmer.

But which is the most creative or the most important?

Traditionally, design has always been seen as the 'Creative Industry', with job titles even being Creative or Creative Director. Programming is often seen as just a case of pressing buttons to make it work. How many times have you met someone with the job title Creative Programmer?

But code-crunching is not necessarily just a button-pressing process. Both elements are integrally symbiotic in the creation of the final product, be that a game, CD-ROM, website or screensaver.

Designers need to work with design-literate programmers and programmers need to work with program-literate designers. That is to say, each side needs to understand the importance of the other.

The best work I have been involved with has been produced when I, the programmer, have sat next to the designer. Not in another room, not in a different office, but there, right next to the designer. This has the effect of creating a circular design process, where ideas feed and breed between the designer and programmer.

The project usually starts with a meeting between the production manager, the designer and the programmer. Ideas are bandied about within the team; about the purpose of the job, the audience, how it should look and how it will work. Each element is equally important and none should be more dominant than the other.

Once the production commences, there is time for the designer to start designing while the programmer can work on back-end issues that aren't critical to the final look of the job.

MICROSITE: A SMALL SITE HOUSED INSIDE A LARGER SITE. THIS CAN TAKE THE FORM OF A GAME,
AN ADVERT, OR EVEN A SPACE TO DEVELOP IDEAS AWAY FROM THE NORM.

```
  SET MODE = 0

  RETURN ME
```

‹01›
LINGO LAVALAMP: PROGRAMMING
A detail from the programming language
that controls the lavalamp.

01

```
                                          Movie Script 3
+  ◄  ►  □                                          [i]   3   [ Internal ]

[global]          ⊞⇄⇆ L☰ ○◉ ⚡

global maxHeat, stageWidth, stageHeight, activeStage

global blob1, blob2

global numberOfChildren

on prepareMovie
  clearglobals

  stageWidth = the stageright - the stageleft
  stageHeight = the stagebottom - the stagetop
end

on startMovie

  set the actorlist = []

  set activeStage = the rect of sprite 120

  set maxHeat = (the width of activeStage/2.0) + the height of activeStage
  --  if maxheat = 0 then maxHeat = 508

  set numberOfBlobs = random (3)

  set MINnumberOfChildren = 3

  repeat with i = 1 to numberOfBlobs
    add the actorlist, new(script"blob object")
  end repeat

  -- set blob1=getat(the actorlist, 1)
  -- set blob2=getat(the actorlist, 2)

  set fromChannel = 11
  set toChannel = fromChannel + MINnumberOfChildren --+ random(2)

  repeat with i in the actorlist
    makeChildren i  fromChannel  toChannel
```

WWW.MOUSE-CANDY.COM

As the designer begins, the programmer can suggest different things that could happen based on the design as it is evolving. Equally, once the project is coming together, the designer can look over the programmer's shoulder and see how things are shaping up, and how things could look and work better. This is where the circular design process begins.

The designer's job is not just a case of designing a few backgrounds and buttons and handing it on to the programmer; the programmer's job is not just a case of linking up a few pages or screens and adding a couple of sound effects. The process is continual, constantly evolving between both developers until the final design is created.

Often it is the naivety of the designer and the project manager in not knowing what is and isn't possible that pushes the programmer to come up with solutions, or to solve problems in a way that their own preconceptions might limit.

THE PROJECT

I have always been interested in interaction and passivity: in other words, objects that do their own thing when left alone, but dance around your mouse if provoked.

The lavalamp does this by behaving as a lavalamp while in its passive state, but if you move your mouse over the blobs, you can drag them around the screen and watch how they react.

The original project started in 1997 while I was in my first job. For a personal project in between real work, I set about trying to create a lavalamp in Lingo using Object Orientated Programming (OOPs).

This version was slow and very basic, with essentially just blob-like graphics moving up and down the screen. The movement was nice, but there was no fluidity to it.

SKILLS

I knew that I was at the outpost of my own programming skills at the time, but I never intended to leave the project there. A couple of years later, while working on another personal project, I noticed some interesting effects when overlaying several blurred images with different ink blends. The effect was one of fluidity: Lavalamp 2.0 commenced.

As both Director and my programming skills had improved immeasurably over the previous years, I started the project from scratch, but using the principles from the two different lavalamp projects.

After a few late nights, the project came together, and it went up on to the website. As the whole thing is basically one graphic and some code, the Shockwave file is only 15k – meaning that even on the slowest of connections, it should download in a couple of seconds.

```
--- CHILD OBJECT ---
PROPERTY POS, DIR, SPEED, HEADING, CHANNEL, MOTHER, DIF

ON NEW ME, LSPRITE, MOM

  SET MOTHER = MOM

  SET CHANNEL = LSPRITE
  PUPPETSPRITE CHANNEL, 1

  IF RANDOM(2) =1 THEN SET X = THE WIDTH OF MOTHER/4.0
  ELSE SET Y = THE WIDTH OF MOTHER/4.0

  SET DIF = POINT(X,Y)

  IF THE CHILDREN OF MOTHER=[] THEN
    SET HEADING = CLICKLOC()
    SET POS = RANDPOS()
  ELSE
    SET HEADING = THE POS OF GETAT(THE CHILDREN OF MOTHER, COUNT(THE
CHILDREN OF MOTHER))
    SET POS = THE POS OF GETAT(THE CHILDREN OF MOTHER, COUNT(THE CHILDREN
MOTHER))+ DIF
  END IF
```

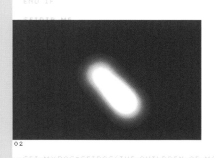

02

03

04

<02-07>
LINGO LAVALAMP: FINAL VERSION
This sequence of images describes how the lavalamp responds to mouse movements.

PROPERTIES AND OBJECTS

The nature of OOPs is a simple but effective one. Instead of programming a graphic to do something, you program an 'object' how to behave in certain situations. Once you have done this, you can leave it alone to look after itself. The other benefit is that once you have told one object how to behave, you can simply reuse that script again and again, creating multiple instances of the object each behaving in their unique way.

In the case of the lavalamp, I didn't just program blobs onscreen to move up and down, but created an environment with virtual heat onscreen, and told the blobs how to behave within that environment.

Each blob has properties of temperature, volume, mass and density; the mass is constant, staying the same throughout, but the rest are affected by one another. I also gave the screen itself a property of temperature and density.

The screen has hot spots and cold spots; the hottest place was in the centre at the bottom of the screen; the coldest in the top left- and right-hand corners.

In every frame, each virtual blob runs through a set behaviour of increasing or decreasing its temperature according to its location onscreen. From this, it adjusts its size ever so slightly, growing bigger for hotter and smaller for colder. From the size of each blob, we can work out the volume of the sprite (width x height x depth – or, as we are only working in two dimensions, just width x height), and then density is calculated by dividing the volume by the blob's mass.

The movement is then created by subtracting the blob's newly acquired density from the screen's density. If the difference is a positive number, the blob will move down by that number of pixels (point 'o, o' is in the top left); if the number is negative, the blob will gently float upwards; if the difference is zero, then the blob will sit weightless until the density either rises or falls.

One of the interesting things about working like this is that as well as needing to dig out your old physics books and concede that yes, your teacher was right, it might come in useful one day, you also discover things that you never expected would happen and that might come in useful in the future.

In early versions of the lavalamp, it would take time to warm up, just like a real lavalamp! The blobs would sit at the bottom of the screen huddled together, slowly reaching up and falling back down again, until they were finally warm enough to break free from the bottom of the screen.

MIXED-MEDIA INSTALLATION: MIXING DIFFERENT MEDIA – SOUND, GRAPHICS, PERFORMANCE – IN AN EXHIBITION SPACE. PROJECTORS AND SENSORS ARE AMONG THE MANY TOOLS USED TO CREATE THE EXPERIENCE.

TO CONTROL.

PROPERTY SPRITENUM -- THE SPRITE CHANNEL NUMBER

PROPERTY ANGLE -- THIS IS THE SPRITE'S POSITION AROUND THE
CIRCLE IN DEGREES, 0 - 360.

PROPERTY CENTERX, CENTERY -- THE CENTRES OF THE CIRCLE. CENTERX =
HORIZONTAL, CENTERY = VERTICAL CENTRE.

PROPERTY STAGEW -- THE STAGE WIDTH

PROPERTY STAGEH -- THE STAGE HEIGHT
-- THESE ARE NOT REALLY NECESSARY HERE, BUT IT
IS HANDY IF THE STAGE MAY BE CHANGING SIZE LATER,
-- SO THAT YOU DON'T HAVE TO ADJUST YOUR CODE.

-- HOLD ON TIGHT, WE'RE GOING IN....

ON BEGINSPRITE ME

 -- DECLARE LOCALS

 -- LOCAL VARIABLE CONTAINING THE MAXIMUM NUMBER OF OBJECTS IN THE SPIN
 MAXOBJECT = 7

05 06 07

END

ON EXITFRAME ME

08

(08)
LAVALAMP VERSION 1: DEVELOPMENT
As the lavalamp warms up, the 'lava' begins to move
around the screen.

 AXIS = (THE MOUSEV - CENTERY) * 0.01

 X = CENTERX + COS(ANGLE * PI() /180) * RADIUS
 Y = CENTERY + SIN(ANGLE * PI() /180) * RADIUS + AXIS

 -- OOOH..... A 'Z'!
 Z = SIN(ANGLE * PI() /180)
 -- THIS SIMPLEST FORM OF SIN, (WHICH I STILL DON'T UNDERSTAND), RETURNS A
NUMBER BETWEEN 1.0 AND -1.0.
 -- WE CAN USE THIS THEN, TO SIMULATE A DEPTH...

 -- THERE ARE NUMEROUS WAYS, FOR EXAMPLE CHANGING THE BLEND OF A GRAPHIC,
OR THE SIZE, ETC ETC...
 --(THIS IS HOW I DID MY CUBE AND SPHERE TYPE THINGS ON MY WEBSITE. I WILL
LEAVE THAT FOR YOU TO WORK OUT....)

 -- FIRST TURN Z INTO A NUMBER BETWEEN 0 AND 2 INSTEAD OF -1 AND 1
 Z = Z + 1

 -- SMALLEST IS THE SMALLEST SIZE WE WANT OUR SPRITE TO BE
 SMALLEST = 60
 SPRITE(SPRITENUM).WIDTH = SMALLEST + (Z * 50)
 SPRITE(SPRITENUM).HEIGHT = SMALLEST + (Z * 50)

 --

 SPRITE(SPRITENUM).LOC = POINT(X,Y)

 -- NEXT INCREASE THE ANGLE FOR THE NEXT TIME AROUND - ACCORDING TO OUR
DIRECTION AND SPEED LOCALS.
 ANGLE = ANGLE + (DIR * SPEED)

END

RESEARCH AND PLAY DEVELOPS CREATIVE THINKING

INTUITIVE PLAY

Creatives have developed research techniques involving play, and have adopted this form of play in a commercial environment.

The interface between research and play is constantly present in interactive media, where designers question their role as advances in technology allow us to produce more interactive work. Communicating with text and image alone is simply not enough. With this in mind, today's designer requires space to explore and develop new methods of how to display information and how it is designed.

MUDs and MOOs are text-only internet game environments in which the player can only describe a scene and his or her actions in text. This method is similar to reading a book in that we use our imagination rather than visualisation, and it appears to contradict the possibilities of what we can actually visually represent on a computer screen. Why then would we want to play a game only with text? Perhaps there are things to be learnt from such a simple game.

We can make comparisons with play in interactive media when we read this quote by John Cage and contrast it to the work featured here:

'And what is the purpose of writing music? One is, of course, not dealing with purposes but dealing with sounds. Or the answer must take the form of a paradox: a purposeful purposelessness or a purposeless play. This play, however, is an affirmation of life – not an attempt to bring order out of chaos nor to suggest improvements in creation, but simply a way of waking up to the very life we're living, which is so excellent once one gets one's mind and one's desires out of its way and lets it act of its own accord.'

John Cage, Experimental Music (1958).

If we are to get the best out of interactive media, designers have to play with the media they are designing for – there is a need to experiment and make mistakes. By making mistakes we find new approaches that allow new methods and systems to develop when applied in a commercial context.

Many designers indicate that play is an important foundation in the development of interactive media. Play is an enriched environment for user and designer, where interactive media cross over into diverse disciplines: interactive film, sound toys and games, etc. Play enables designers to negotiate new forms and set new boundaries for multimedia as previously distinct formats now blur and overlap.

Game design is pure play: we go on adventures, accept challenges and engage in fantasy and role-playing. Children today grow up in a world where the internet's place in society and culture is a given, since many homes have a personal computer with internet access, and networked computers are used widely at school. Traditional toys and games are often silent – board games and dolls have now been replaced by Playstations, Gameboys and robot dogs.

Play is natural; it is a physical human condition that is expressed physically and emotionally. Interactive media attempts to create new forms of play, exploring the nature of how things work and how we create new experiences.

<01-05>
ROM:ONE
Images from the Rom and Son experimental CD-ROM: interactive music games,
airport seating game, flash film, tea pouring game and interactive music.

01

02

03

DESCRIPTION

PROJECT: ROM:ONE
BRIEF: SELF-INITIATED
DATE: 2001
DESIGN AND PROGRAMMING:
ROM AND SON
TECHNOLOGY: DIRECTOR MOVIE, FLASH
FORMAT: CD-ROM

<06>
SOUND INSTALLATION FOR PAUL SMITH
Displayed in Paul Smith's shop window.
Passers-by trigger animations that respond
to sound, movement and conversation.

06

ROM AND SON

My first building block for discussion
of where the cross-over of play and
commercial work appears is London-
based studio Rom and Son. They
weave an invisible thread through
interactive design that is both playful
and serious. After all, work should
include having fun; if it's your
favourite hobby, then let it be fun.

The work pictured here represents
the studio's creative output for
expression, ROM:ONE. This is a CD-
ROM of work that is described by
Rom and Son as a sound game story.
Although this CD-ROM work is of
experimental form, when Rom and
Son work in the commercial space of
retail design, the distinction between
what is experimental and what is
commercial seems to disappear (as
in the case of a sound-interactive
installation in fashion designer Paul
Smith's Covent Garden store).

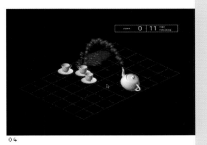

04

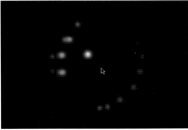

05

(07-08)
METHOD LAB: MOUSETRAILS
This microsite by Method plays with the interface of mouse movement and the revealing of information. When the user's mouse is moved around the screen, previously invisible numbers appear.

07

08

METHOD LAB

San Francisco designers Method created Method Lab as an area that allows them to flex their creative muscles. Playing with the medium allows artistic impulses to cross over and merge, introducing ideas for development that are not necessarily concerned with finalised solutions. It is a space for them to express limitations and to explore expectations of what the web could be.

This is a container for artistic expression where the experience of play finds itself influencing corporate developments. Method Lab is a play centre that informs Method's commercial studio work, where they develop experiments that could fail or become successful. Method use this space as a breeding ground for creative evolution. They are attempting to push the boundaries with work that explores the intersection of three-dimensional interface design and sound, as well as experiments with visual navigation that do not rely on tabs.

DESCRIPTION

PROJECT: METHOD LAB
BRIEF: SELF-INITIATED
DATE: ONGOING
DESIGN AND PROGRAMMING: METHOD
TECHNOLOGY: DIRECTOR
SHOCKWAVE, FLASH
FORMAT: MICROSITE

09

10

(09-10)
METHOD LAB: KUBISM
Method Lab developed this application to allow the user to build models that could take the form of a navigation system.

DESCRIPTION

PROJECT: WHEN I THINK OF HEAVEN...
BRIEF: SELF-INITIATED
DATE: 1998
DESIGN AND PROGRAMMING:
DOMINIC ROBSON
TECHNOLOGY: MIXED MEDIA
FORMAT: INSTALLATION
LOCATION: ROYAL COLLEGE OF ART
GALLERY SPACE, LONDON, UK

DOMINIC ROBSON

Digital media offers very rich potential for creating and manipulating sound and music in new and different ways. The theme in this work is to look at ways in which artists can fully exploit the emerging technologies to create interfaces that in some way ignore or challenge some of our established notions.

<11>
WHEN I THINK OF HEAVEN...
This interface allows a number of people to play with sound and music together in an unusual physical and playful way. Using four stretch panels and two percussion pads, the interface is immediately responsive to players who want to make music. Each part of the interface creates a sound as soon as there is any nominal interaction. The two lower stretch panels play a tone that bends up in pitch as you push your hand into the wall.

WWW.DIGIT.COM

DESCRIPTION

PROJECT: DIGIT WEBSITE
BRIEF: COMPANY WEBSITE
DATE: ONGOING
DESIGN AND PROGRAMMING: DIGIT
TECHNOLOGY: MIXED MEDIA
FORMAT: WEBSITE

DIGIT

The digital vision of Digit, designers of WWW.HABITAT.NET and award-winning WWW.MTV2.CO.UK, take this form of play a step further. Digit believe that design must be involving as well as effective, and they have continued to gain a reputation as providers of some of the most inventive new media design services to major corporations. Part of this success springs from deliberately giving over a percentage of their time to research and development, or as Digit prefer to call it 'Research and Play'. They quote the saying that, 'As a wise man once said, "the opposite of play is not work but depression."' It is no accident that a good proportion of their work for clients evolves out of playful experiments that clients have related to. This experimentation is rewarding for designers and clients alike, and their work is often a wonderful source of inspiration.

GO TO >>> 116

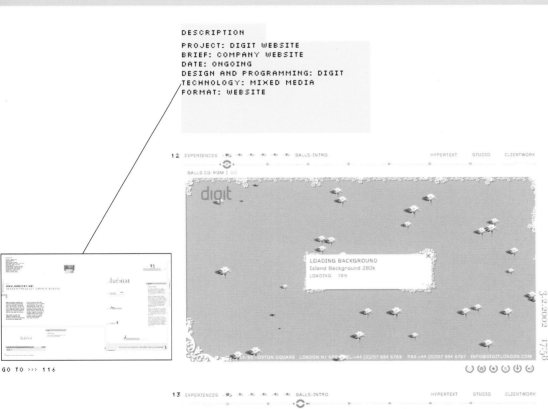

<12-13>
DIGIT WEBSITE
Digit's own website is playful and engaging. Changing the environment you are in brings new experiences, altering the sound you hear and how the interaction feels.

IDEAS, PROJECTS & SCENARIOS

Design frontiers are forever changing: reflecting, reacting to and accommodating the ever-widening need for internet-based communication. But how often do we surf the net, and what makes us surf? From logging on for the daily news digest to checking email and instant messaging, design is constantly challenged to develop compelling reasons to engage with new media, before attention is snapped elsewhere.

Speed has become a pervasive issue in many aspects of life: at the newsagents we browse through titles that we don't really read. How often do we actually read what's on the page? It seems as though we only ever take a glimpse. The same appears true for many other forms of media: with music, the latest chart-topping album is often bought only to be listened to once before the buyer hurries out to buy the next.

We are bombarded with information, so much so that the feeling of truly being able to read or listen is perhaps rare. Or, are we simply changing our patterns of communication as more options and possibilities become available? The internet is particularly good at connecting people – but what would it be like to visit a retail shop online and actually 'see' other people at the same time?

This chapter presents digital projects and studios chosen to reflect current working practices. Demonstrating different models of working and creative diversity, it covers most, if not all, production methods. This chapter shows designers coming from a print background how designing for the internet need not involve a dizzying array of web bells and whistles and the latest plug-ins, but a space of infinite possibility, to enhance the user's experience and to give the designer more opportunity to allow the design to flow.

Of the work profiled here, one of the most interesting is Method's: even though they are a design studio, their website is very minimal and understated. However, it does make you want to stop and look more closely – its black and white colour scheme defies the all-colour web convention, offering a pleasing and welcome break.

Another project, the interactive music studio website, is aimed at seven- to eleven-year-olds. Through the use of puzzles and games, it teaches children how music can be visually explored, providing a new interface for musical creativity that enables a whole new audience to become engaged.

For UK furniture store Habitat, Digit realised a powerfully evocative vision of what online shopping could be – translating the cool sense of product and interior design and the lifestyle identity of the brand into a fun and engaging website. It enhances the identity of the Habitat brand by creating a sense of how its designs could be lived with, without the stress of actually visiting the store. The detail on the site is humorous, adding just that little bit extra to the experience of online browsing and shopping that so many retailers are unable to capture either online or off.

Tota Hasegawa's Microphone Fiend is a beautiful representation of what interactive media can be, and demonstrates that designing for the screen isn't just about making something look pretty. Design needs to bring people together and make them forget what they are actually looking at, just as the cinema is a place to take time out from daily life and become immersed in imagination. Microphone Fiend does the same – the interface of a phone booth allows a user wearing a pair of headphones to become lost in the interaction. By blowing into the microphone, the interface is opened and the user is greeted by a screen that floats above the desktop. This interface makes us use our senses – we blow to make sound, we use our eyes, we use our hands, all that's missing is taste – but then this work has a visual taste...

THE CREATIVE PROCESS BRINGS TOGETHER MANY PEOPLE WITH DIVERSE WORKING PRACTICES, WHOSE SKILLS ALL COME TOGETHER IN THE CREATION OF THE FINAL SITE.

Any designer could be commissioned to make a site – the projects featured here work through a variety of merits: from design simplicity to strong typography. What these projects have in common is that they are all examples of a process of questioning the role of the designer – whether in print, film, internet design or product design.

We are now witnessing a space where graphic identities that have previously worked well in the print environment have to be redesigned so that they work well across all media. Sometimes this happens because a print logo is applied to the internet but simply doesn't feel comfortable in the medium. Sometimes a design might need to cross over into the print environment, or a TV advert might need to be created – the design then has to work across all platforms. What works well in print might get lost when applied to the screen. As the world comes to rely more and more on screen-based interaction, design might be forced to focus on the screen and then work back for print.

Interactive identities offer new ways of thinking about communicating an identity or brand – logos that are designed to be visualised as stationary objects might also have animated versions, as perhaps an interactive character. Such an interactive identity doesn't even have to be visual anymore, it could be a sound, it could be made by the user, it could even be generative – created live through programming.

The internet challenges established working practices. The large number of small design groups and collectives, along with the mobile office (a laptop with an internet connection) means that studio-based design is more flexible and collaborative. By pooling talents, the creative process brings together many people with diverse working practices, whose skills converge in the creation of the final site.

The interactive music studio (for Channel 4 and the Department for Education and Employment) demonstrates how a large and complex site can be put together without the need for a big design studio, but by individuals working together via the web, rather than in the same space. These approaches to working develop from a do-it-yourself approach common to many artists and designers used to working alone or in small groups rather than in large design firms. The internet enables greater association between collaborators to share skills and participate on specific projects while retaining their independence.

The fact that a design team might be geographically spread out is no longer an issue, since communication via email and other internet technologies (such as instant messaging) have become so common. Thus designing for the internet causes designers to share and use the same virtual space and tools for the medium in which they are working. The internet is itself an environment for developing ideas and testing them. Unlike print, we don't need to be close to the printer to test out ideas – prototypes for the internet can be uploaded and tested either publicly or for a select group in minutes, with physical location not being an issue at all.

This leap in working practices is one of many factors that allows for people with diverse skills to work together. As the technologies of communication become ever more sophisticated, they require complex solutions that draw upon many different disciplines. It is no wonder, then, that the hybrid product of such multi-faceted collaboration is often the most interesting.

DESCRIPTION
PROJECT: GRIDCLUB MUSIC STUDIO
CLIENT: CHANNEL 4, DFES
DATE: 2001
DESIGN: STUDIOTONNE
PROGRAMMING: STARDOTSTAR
PRODUCTION: BIG HEART
ILLUSTRATION: JOE BERGER
FORMAT: MICROSITE
TECHNOLOGY: DIRECTOR SHOCKWAVE,
FLASH, BEATNIK, HTML

BIG HEART/STUDIOTONNE/STARDOTSTAR/JOE BERGER

GRIDCLUB MICROSITE
CHILDREN'S ONLINE LEARNING

WWW.GRIDCLUB.COM

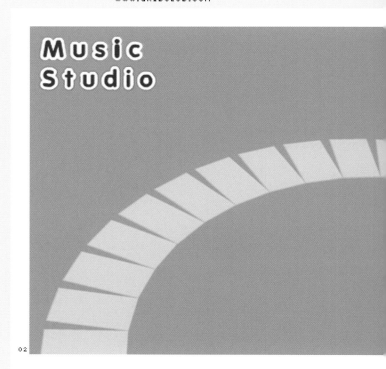

02

Music Studio was commissioned in the UK by Channel 4 and the DFES (Department for Education and Science). Part of the GridClub website for schools aimed at seven- to eleven-year-olds, Music Studio teaches children to develop a musical ear through the aid of puzzles and games.

A main concern for the designers was that file size, image and programming alone would have made the download times too long, so the designers utilised the small file sizes that can be generated from Flash as vectors and embedded these straight into the Shockwave part. Director was then used to control the mixture of media, Flash, MP3 and Midi (Musical instrument digital interface).

As three companies produced the microsite, effective collaboration between designer, programmer and illustrator was essential due to location issues (with studios in three different UK locations). A project of this size and nature using print would have resulted in lots of meetings and train journeys. Due to the ease in which websites can be updated, all ideas, development and production work was carried out online on a central server. Email and phone correspondence provided the daily communication link, while meetings took place every couple of weeks.

01

NAVIGATION: MOVING BETWEEN WEBSITES AND INTERNET-BASED INFORMATION, EITHER IN A DIRECTED OR RANDOM FASHION.

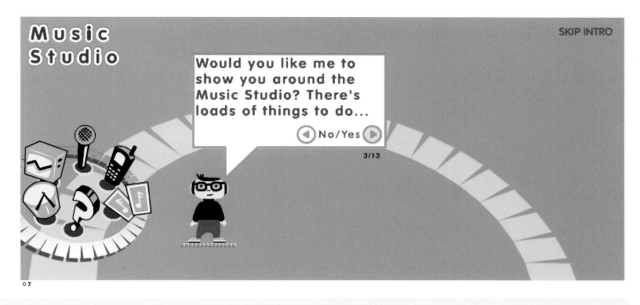

⟨01–03⟩

ONLINE HELP

Foreseeing that children might get bored with a
text-based help system, online help was provided
in the form of the Groover. Once prompted by the user,
this character provided instant help and support and
would sometimes feature in the game.

Reflecting the need to bring fun and inspiration to
online education and learning, the mood and style
given to the Groover's character meant that game
play wouldn't look out of place next to a Gameboy
or Playstation-style environment.

⟨04⟩

NAVIGATION

Navigation was designed to reflect an exciting music
studio. In the studio are links to games and challenges
such as Karaoke Songwriter, Mobile Melodies, Music
Match, What's that Sound?, Drum Composer and
Movie Composer. The title and a brief description of
the game appears as the user moves their mouse over
one of the symbols.

Navigation placed on the left-hand side of the screen
is designed and programmed in Flash. It downloads to
the required game through a series of links that control
the Director Shockwave games.

34

IDEAS, PROJECTS & SCENARIOS

LOADING SCREENS

The file sizes created by using Flash or Director alone would have made the download times too long to be viable for children connecting to the site on a 56k modem. So the microsite used the development environment of Director to harness and integrate Flash, Shockwave, Midi and MP3 technology wherever appropriate.

A bespoke download object was then created to download different levels of each game seamlessly in the background. This intelligent object calculates the order in which the user is expected to move through the site. If the user jumps to a level out of sequence, the object adjusts the order of the download sequence automatically.

Loading screens were designed to allow the user to see the progress of the game downloading.

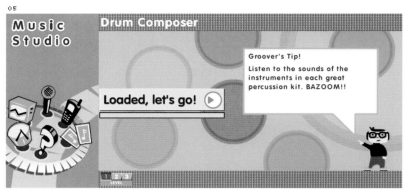

⟨ LIBRARY MGCADT ⟩ (stamp)

GAME: MUSIC MATCH

This game was based on the card game 'Pairs',
where players take turns to uncover and recover
pairs of cards, winning the pair if the images match.
For this online version, instead of just guessing image
combinations, the user has to match sound and
image combinations.

GAME: MOBILE MELODIES

Children are encouraged in their play by introducing
the mobile phone as an educational tool alongside
more conventional images of drums and
percussion instruments.

DESCRIPTION

PROJECT: METHOD.COM
BRIEF: COMPANY WEBSITE
DATE: 2000-ONGOING
DESIGN AND PROGRAMMING: METHOD
FORMAT: WEBSITE DESIGN PORTAL

METHOD

WWW.METHOD.COM
WEBSITE/DESIGN PORTAL

Method is an interdisciplinary design firm located in New York and San Francisco. It specialises in identity design, communication design and interface design. By combining the talents of typographers, brand strategists, interaction designers, technologists and graphic designers, Method is able to provide its clients with complete branding systems in both analogue and digital media.

The Method website was created specifically to highlight its client work. The 'brand' of Method is downplayed to help elevate the importance of the client solutions. It was also designed to introduce the design firm's thinking, design work and their culture to the world at large.

The look and feel of the interface realises the desire to narrow the gap between print and web environments. Typographic rules that are typically more specific to print were applied to this site.

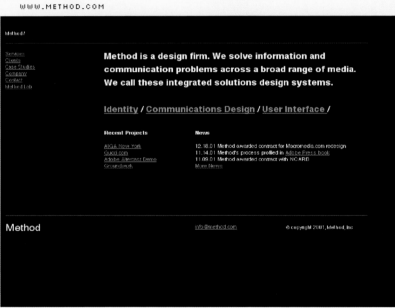

01

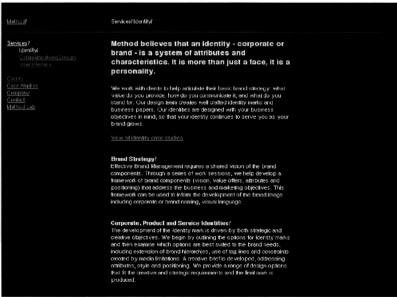

02

Method/

Method/ Company/ Clients/

Services
Clients/
 Testimonials

Case Studies
Company
Contact
Method Lab

Art and Cultural Institutions/
AIGA New York
The Film Society of Lincoln Center*
MoMA, New York
New Langton Arts
Open Office
Storefront Gallery*

Business Services/
Buzzsaw.com
Express Action
Need2Buy
provenir
Studio Direct
Tradeweave

Consumer Electronics/
Logitech
Quantum
Toshiba

Fashion/
aeiou*
Gucci

Financial Services/
Clearstation
Dotbank (acquired by Yahoo!)
Encirq
eTrade
Merrill Lynch

Media/
Atom Films
BBC
MSN (television ads)
MTV

Medical/
ePhysician

Non-Profit Organizations/
Groundwork/FAO
Tsunami Fund

Professional Associations/
Consumer Electronics Assoc.*
NCARB*

Professional Services/
Ackerman McQueen
Applied Communications
Daniel Proctor Photography
Ernst and Young
Fort Point Partners
IDEO Product Development
Kinetic Solutions
Lexicon

Publications/
Consumer Review
Style365

Recreation/
boats.com

Retail/
The Apartment
Camdens
Ultimate Health Media*

Software/
Adobe Systems
Autodesk
Embarcadero Technologies
Intuit
iPlanet
Macromedia*
Moreover
musicbank
Netscape
Packet Video
personify
Pulse
Radiance
Solid
Sun Microsystems
Support.com
Swan Systems
Verb

Telecommunications/
fusionOne
Omnisky

Travel/
TRIP.com

* = currently in development

Method info@method.com © copyright 2001, Method, Inc

⟨01–05⟩

GRID STRUCTURE

⟨01–04⟩ The Method site is built on a four-column grid. This structure has more in common with grids found in print work than with those found on traditional HTML websites. The clarity of the site is emphasised by the introductory statement displayed, 'Method is a design firm. We solve information and communication problems across a broad range of media. We call these integrated solutions design sytems.'

IDENTITY

⟨05⟩ The HTML typography is standardised with three different weights. Even the Method 'identity' on the site is represented with HTML text. Again, the ultra-simplistic approach, which paradoxically creates rather a sophisticated look, is emphasised in their introductory statement to their identity work: 'Method believes that an identity – corporate or brand – is a system of attributes and characteristics. It is more than just a face, it is a personality.'

Method/ Company/ Clients/

Services
Clients/
 Testimonials

Case Studies
Company
Contact
Method Lab

Art and Cultural Institutions/
AIGA New York
The Film Society of Lincoln Center*
MoMA, New York
New Langton Arts
Open Office
Storefront Gallery*

Business Services/
Buzzsaw.com
Express Action
Need2Buy
provenir
Studio Direct
Tradeweave

Consumer Electronics/
Logitech
Quantum
Toshiba

Fashion/
aeiou*
Gucci

Financial Services/
Clearstation
Dotbank (acquired by Yahoo!)
Encirq
eTrade
Merrill Lynch

Media/
Atom Films
BBC
MSN (television ads)
MTV

Medical/
ePhysician

Non-Profit Organizations/
Groundwork/FAO
Tsunami Fund

Professional Associations/
Consumer Electronics Assoc.*
NCARB*

Professional Services/
Ackerman McQueen
Applied Communications
Daniel Proctor Photography
Ernst and Young
Fort Point Partners
IDEO Product Development
Kinetic Solutions
Lexicon

Publications/
Consumer Review
Style365

Retail/
The Apartment
Camdens
Ultimate Health Media*

Software/
Adobe Systems
Autodesk
Embarcadero Technologies
Intuit
iPlanet
Macromedia*
Moreover
musicbank
Netscape
Packet Video
personify
Pulse
Radiance
Solid
Sun Microsystems
Support.com
Swan Systems
Verb

Telecommunications/
fusionOne
Omnisky

Travel/
TRIP.com

06

Method/

Services
Clients
Case Studies
Company
Contact
Method Lab

Method

07

Method/

Services/
 Identity
 Communications Design
 User Interface

Clients
Case Studies
Company
Contact
Method Lab

Method

(06—10)

SITE ARCHITECTURE

The information architecture was conceived to allow users to quickly understand what Method does, who they work with, what that work looks like and who they are.

The goal was to create a 'pure' HTML website to show that web design need not be reliant on 'bells and whistles' and gratuitous animation. The concept and design of this site relies heavily on the information architecture and the client case studies to help potential clients quickly understand what Method does.

Main content headers are kept to a minimum. Once clicked on, they appear white, while section information opens into grey. By clicking on another sub-section heading, that will also turn white while all other information remains grey.

08

Method/

Services
Clients
Case Studies
Company/
 Awards
 Publications
 Job opportunities
 Leadership
 News
 Strategic Partners

Contact
Method Lab

Method

09

Method/

Services
Clients
Case Studies
Company/
 Awards
 Publications
 Job opportunities/
 Senior interaction designer
 Graphic design intern
 Interface technology intern

 Leadership
 News
 Strategic Partners

Contact
Method Lab

Method

hod/

vices
nts
e Studies/
npany
ntact
hod Lab

Sort by: **Industry**, Identity, Communications Design,

Client Identity

Art and Culture

MoMA, New York

Open Office

The Film Society of Lincoln Center

New Langton Arts

Jim Pomeroy

Business Services

Buzzsaw

Provenir ●

Studio Direct ●

Tradeweave ●

Consumer Electronics

Logitech

Quantum Portfolio ●

Media

Atom Films ●

Gooey

MSN (television)

Pop.com ●

Urban Box Office ●

Professional Services

Proctor Photography

Fort Point Partners

Kinetic Solutions ●

DESCRIPTION

PROJECT: 23RD FLOOR
CLIENT: BT CELLNET
DATE: JUNE 2001-ONGOING
DESIGN: AIRSIDE
TECHNOLOGY: HTML, FLASH,
SHOCKWAVE
FORMAT: WEBSITE

100

AIRSIDE

WWW.23RDFLOOR.CO.UK
WEBSITE/GAMES

‹01›

LOGO, LOOK AND FEEL

Airside decided to find a name that was a place, and that was flexible enough to be used not just for a website, but for a clothing label, a club or anything else; they chose 23rd Floor. All sorts of names were generated, like 'Auntie Mavis's Kitchen' and '16 Roseberry Crescent', but 23rd Floor hit the spot and all parties agreed to go ahead with it.

The next stage in the design process was to generate logo ideas. As 23rd Floor is a place, Airside decided to play around with the logo looking like part of a building, and it ended up like this – on the corner of a block with a bit of perspective on it – with quite an American feel to it.

The 23rd Floor website is a joint venture between Airside and BT Cellnet aimed at the 16–24-year-old market. It's a place where BT Cellnet can post all their new mobile phone games and get them up and running very quickly.

The brief was to create a new brand that will become the home of the latest mobile games. The end product needed to embody a unique underground identity that could be conveyed via a vibrant website and a range of exciting real-world activities.

Airside conceived 23rd Floor as a brand that would effortlessly lend itself to a whole plethora of other offline media, from clothing labels through to club nights and gallery exhibitions. Through the use of a vibrant colour palette and quirky navigation menus, the site has the feel of a digital playground where strange things happen at the click of the mouse.

we are so happy that
we found "txtm8s"

02

ONLINE COMMUNITY: AN ONLINE SPACE WHERE PEOPLE GET TOGETHER TO CHAT ONE-TO-ONE OR CONVERSE IN DISCUSSION GROUPS.

02

03

04

peter peter timmy jane peter

<02-05>

PERSONALITIES

The site is an experimental platform for mobile
phone games, so the characters that inhabit the site
and show you how to play the games are derived from
game graphics. These characters also appear in a sub-
site within 23rd Floor called the Unfair. It was a
Funfair, but the F fell off and it became Unfair. It's a
chat room where you choose an avatar to represent
you. You can choose your clothes, hats and masks,
and go and make friends and play online games.

<06>

WEBSITE IDENTITY

The visual identity for the website was decided by
simply playing around until Airside found something
that worked. The diagonal line extending from the
diagonal of the logo sets the tone.

23ᴿᴰ FLOOR

05

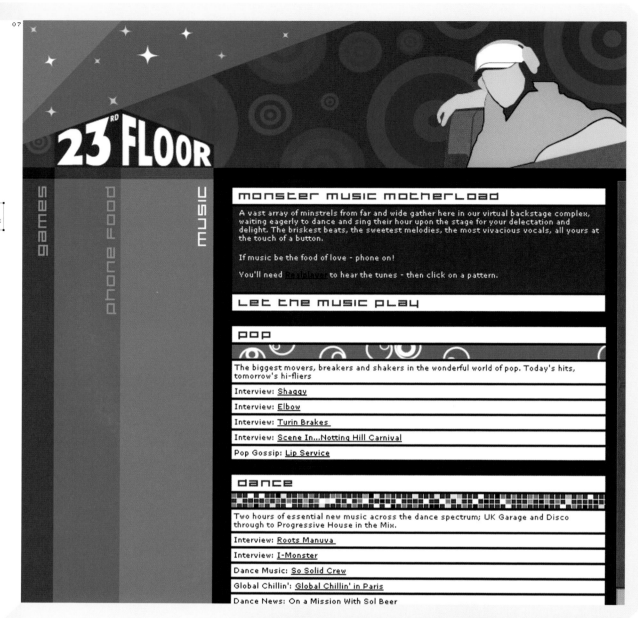

games

phone food

music

monster music motherload

A vast array of minstrels from far and wide gather here in our virtual backstage complex, waiting eagerly to dance and sing their hour upon the stage for your delectation and delight. The briskest beats, the sweetest melodies, the most vivacious vocals, all yours at the touch of a button.

If music be the food of love - phone on!

You'll need Realplayer to hear the tunes - then click on a pattern.

Let the music play

pop

The biggest movers, breakers and shakers in the wonderful world of pop. Today's hits, tomorrow's hi-fliers

Interview: Shaggy

Interview: Elbow

Interview: Turin Brakes

Interview: Scene In...Notting Hill Carnival

Pop Gossip: Lip Service

dance

Two hours of essential new music across the dance spectrum; UK Garage and Disco through to Progressive House in the Mix.

Interview: Roots Manuva

Interview: I-Monster

Dance Music: So Solid Crew

Global Chillin': Global Chillin' in Paris

Dance News: On a Mission With Sol Beer

08

⟨07-08⟩

COLOUR

The colours work so that each section consists of tones of one colour. The homepage is designed in browns, the music blues, the games reds and the food greens. This colour scheme enabled Airside to make the site very colourful without looking too tacky.

MAIN CONTENT

The content was divided into three main areas – games, phone food (everything that feeds your phone – ring tones and icons, etc) and music. Anything that doesn't fit into these categories, like the message board and the screensaver, becomes a block above the 23rd Floor logo.

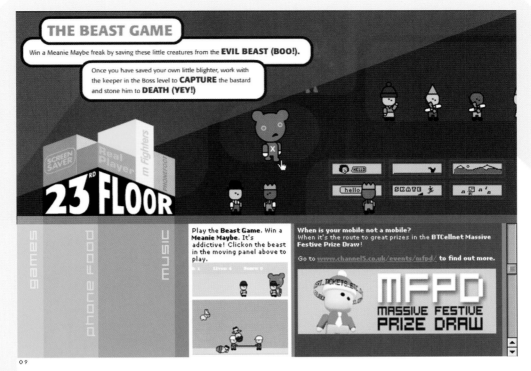

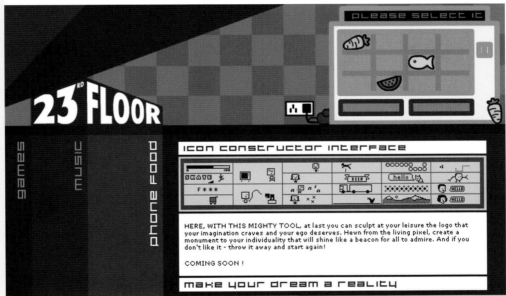

⟨09–10⟩

NAVIGATION

The blocks that sit on the logo also followed the building theme. They are quick links to the bits of the site that don't fit anywhere else, or the bits that the designers really want people to go to. The blocks build up the storeys of the 23rd Floor edifice.

TYPOGRAPHY

Hi Score is used as the main typeface. It looks like a two-bit screen font that you might find on your phone – it has no anti-aliasing, so it makes small file sizes and still appears very strong.

DESCRIPTION

PROJECT: ARNODESTANG
CLIENT: COMPANY WEBSITE
DATE: 2001
PRODUCTION, DESIGN AND
PROGRAMMING: JOE BERGER
TECHNOLOGY: FLASH, PHOTOSHOP,
FREEHAND, HTML
FORMAT: WEBSITE

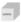

WWW.ARNODESTANG.CO.UK

104

IDEAS, PROJECTS & SCENARIOS

JOE BERGER

WWW.ARNODESTANG.CO.UK
WEBSITE/SHOWCASE

Joe Berger is an illustrator and animator involved in telling stories. The fundamental problem with interactive stories is of how to keep control of pace and story, etc, if the viewer is controlling it. In the case of this website, the site is a showcase for Joe's work, but it's also the home of a fictional character called Arno De Stang. The story is that Arno is out when the user arrives at the website, and he has left his niece Bridget alone. She's in a box for her own safety, and the user can let her out of the box if they want.

A new type of storytelling welcomes the user to explore the work in this site. It opens up a new space for showcasing work because instead of just offering an online portfolio, the site works on two levels. On the first level, one's personality outside of the work is brought to life when the girl character is added, and, on the second level, because of this the work is made more interesting to view within a narrative framework.

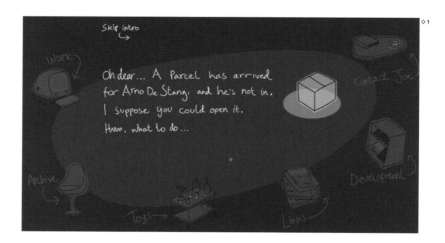

01

<01>

NAVIGATION

The opening page of the website is introduced with a small narrative 'Oh dear... A parcel has arrived for Arno De Stang, and he's not in. I suppose you could open it. Hmm, what to do...'

Berger likes the fact that the action happens off-screen – which also means Joe doesn't have to do masses of animation. This is creatively satisfying, since it's good to leave some things to the imagination of the viewer.

PALM PILOTS: HANDHELD COMPUTER THAT CONTAINS SELECTED FEATURES OF A FULL-SIZE COMPUTER.

02

(02-04)

DRAWING

The animation was drawn by hand and scanned in.
Once it was working correctly, Joe redrew it in Flash,
to make a vector-based version. Joe drew with a Wacom
tablet on screen, which he finds really satisfying.
Berger feels that working in this way makes 'you get all
the benefits of the hi-tech medium, while retaining
(hopefully) the idiosyncrasies of traditional drawing.'

03

04

05

06

(05-06)

TYPOGRAPHY

Berger enjoys the anti-design aesthetic of handwriting
the text on the site – it makes it feel quite spontaneous,
almost as if it's been doodled in the margins of an
exercise book.

07

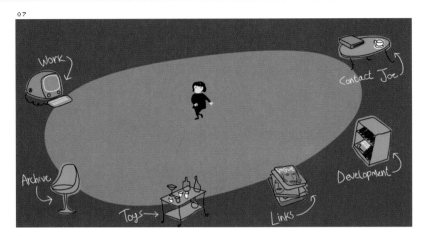

08

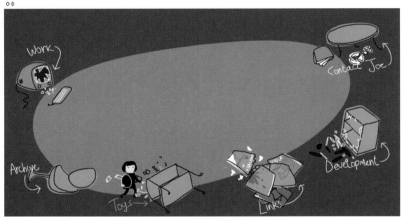

09

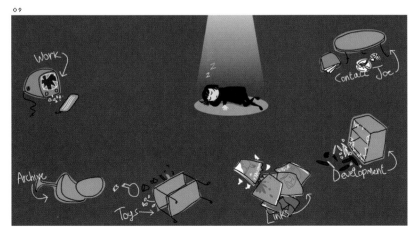

NAVIGATION

〈07-09〉 You can simply browse the various galleries on the site, and look at the original Arno website in the archive. However, if you let Bridget out of the box, she runs round after the mouse, and eats it if she catches it. If you then browse the site, each time you return to the homepage, the story has progressed: the first time you return, Bridget has trashed the place – all Arno's things (which are links to the different areas of the site) have been knocked over and broken. The next time, Bridget has fallen asleep. The time after that, (this has yet to be implemented) Arno has returned, and stands fuming amid the ruins of his home.

WORK SECTION

〈10〉 Fun icons allow sub-sections to be viewed more easily.

CREATIVE RESEARCH

〈11-13〉 The brain signifies Arno De Stang's creative area of the site. The description 'sssh... be very quiet this is where the thinking goes on', describes the concept of his work in a gentle and effective way.

PDF 〈PORTABLE DOCUMENT FORMAT〉: A FILE FORMAT THAT IS CREATED IN ADOBE ACROBAT AND MAINTAINS THE ORIGINAL RESOLUTION OF IMAGE AND TEXT. THIS MEANS THAT THE IMAGE REMAINS SHARP BUT LOW IN FILE SIZE.

From this page you can access a small but perfectly formed selection of my work corralled into the four loose catagories below. Be sure to check out the Archive & Development sections of the site aswell.

CLIENT LIST

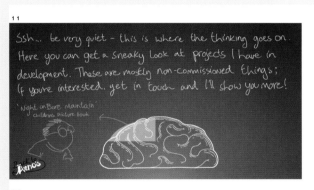

Illustration

Web animation

Book Covers

Broadcast animation

Back to Arno's

Ssh... be very quiet - this is where the thinking goes on. Here you can get a sneaky look at projects I have in development. These are mostly non-commissioned things; If you're interested, get in touch and I'll show you more!

'Night on Bare Mountain' children's picture book

Back to Arno's

Ssh... be very quiet - this is where the thinking goes on. Here you can get a sneaky look at projects I have in development. These are mostly non-commissioned things; If you're interested, get in touch and I'll show you more!

'Covert' short animated film

Back to Arno's

Ssh... be very quiet - this is where the thinking goes on. Here you can get a sneaky look at projects I have in development. These are mostly non-commissioned things; If you're interested, get in touch and I'll show you more!

Bridget FIDGET

More on this soon!

Back to Arno's

DESCRIPTION

PROJECT: SUSSED
CLIENT: OLDHAM ART GALLERY AND
MUSEUM, MANCHESTER, UK
DATE: 2001
DESIGN: GERARD O'BRIEN
PROGRAMMING: GARETH LANGLEY
PRODUCER/ARTIST: MARIA N STUKOFF
TECHNOLOGY: DIRECTOR MOVIE
FORMAT: VIDEO PROJECTION
INSTALLATION
WEBSITE URL:
WWW.SUSSED-EXHIBITION.CO.UK

108

STARDOTSTAR

SUSSED
GALLERY INTERFACE

The brief was to create an interactive installation for 'Sussed', the maiden exhibition for Oldham's new purpose-built art gallery. The exhibition would show 29 paintings, photographs and sculptures arranged thematically around the walls of the gallery to examine issues of sustainability. Each work had four key words from the Earth Summit's Agenda 21 (1992) associated with it. The purpose of the installation was to show how our lives connect with each other and our built and natural environments, and to reinforce the links between the paintings in relation to sustainability.

01

<01>

CLIENT SKETCHES

The client developed ideas to describe to the designers the role that the interface would have alongside more contemporary gallery artworks.

PIXEL: THE SMALL SQUARE DOTS THAT IMAGES ARE MADE UP OF ON A COMPUTER SCREEN. THE NAME REFERS TO HOW MONITORS DIVIDE THE DISPLAY SCREEN INTO THOUSANDS OR MILLIONS OF INDIVIDUAL DOTS DEPENDING ON THEIR VIEWING RESOLUTION.

04

05

06

<02-06>

ROUND INTERFACES

Designing for the round interface was something
that really interested Stardotstar from the start. The
whole screen needed to be legible or understandable
from all directions at the same time, with no one side
taking precedence. As the theme was sustainability, a
round table and interface seemed more logical than
square, as a square shape held confrontational
connotations and the installation needed to promote
the idea of co-operation. This idea was carried through
every level of the design. The images are shown as
crops within circles, which slowly rotate as narratives
are heard over the top.

02

03

<07>

CREATIVE DECISION-MAKING

Before any project commences, there are usually a number of considerations that designers have to take into account.

Firstly, with a limited budget for equipment, Stardotstar knew that they could only have one computer and a projector. In a gallery or museum, you generally want to have as many people using the installation as possible at any one time, otherwise you will end up with a queue of people all waiting to use the device.

Once the visitors get to have a go themselves, generally they feel shy to press the buttons in case they get it 'wrong' in front of an audience, or in case it makes loud noises that can be heard across the entire auditorium. Behind them will be the queue of people breathing down their necks, all desperately wanting their go. The net result is that after three clicks, the intimidated user will be embarrassed and will run off to look at something else.

110

IDEAS, PROJECTS & SCENARIOS

07

<08-09>

THE INSTALLATION

After much debate and deliberation, Stardotstar decided to build a round table with a video projection in the middle and buttons around the side. This would allow up to four people to join in at the same time, and also allows more people to view the proceedings without intimidating the people playing.

The installation has no beginning and no end; people can walk up and join in, or walk away at any time without interruption to the flow of the game. The game plays by itself, but at any time between one and four people can join in and influence the direction that the game will take. The state that the game is left in will affect the next generation of users.

08

PLATFORM: WHEN DESIGNING A WEBSITE, IT IS NECESSARY TO KNOW WHAT PLATFORM THE WEBSITE IS DESTINED FOR (LIKE NEEDING TO KNOW THE SIZE OF PAPER IN PRINT DESIGN). IT IS IMPORTANT THAT ALL DESIGNS ARE PLATFORM-COMPATIBLE, AS DIFFERENT WEB BROWSERS DISPLAY INFORMATION DIFFERENTLY DEPENDING ON WHICH PLATFORM IS USED. 'PLATFORM' DESCRIBES THE TYPE OF MACHINE AND OPERATING SYSTEM THAT YOU USE, EG, MAC OS.

DESCRIPTION

PROJECT: THISISREALART
ONLINE GALLERY AND SHOP
CLIENT: THISISREALART
DATE: JANUARY 2001
DESIGN: NIMA FALATOORI
PROGRAMMING: WILF JOHNSTON
AND ANDY WHITE
CREATIVE DIRECTION:
ADRIAN SHAUGHNESSY
TECHNOLOGY: HTML, JAVASCRIPT,
MICROSOFT ACTIVE SERVER PAGES
(VB SCRIPT), ACCESS DATABASE
FORMAT: ONLINE GALLERY AND SHOP

INTRO

WWW.THISISREALART.COM
ONLINE SHOP/GALLERY

As an online shop and gallery, thisisrealart commission leading designers, photographers and artists to produce works of art to be sold exclusively on the thisisrealart website in limited editions.

Work is a mixture of silkscreen, photographic and digital prints. Because of the democratic nature of the internet, online art galleries are available to all users regardless of their status or location. Lack of overheads means that anyone can set up their own online gallery.

01

02

03

(01–04)

DEVELOPMENTAL RESEARCH

The initial concept was to develop a clean utilitarian website that displays up to 15 pieces of work at a time. The navigation of the images is based on this fact.

A navigation interface was explored that could be played with by the user's mouse. These exercises developed into working themes that are visible in the final site's navigation.

04

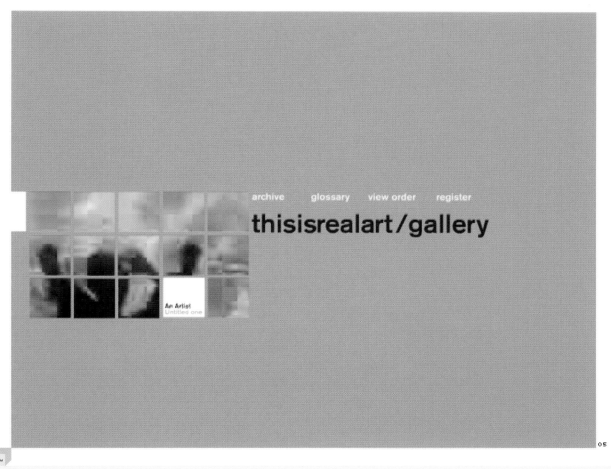

thisisrealart/gallery

archive glossary view order register

An Artist
Untitled one

05

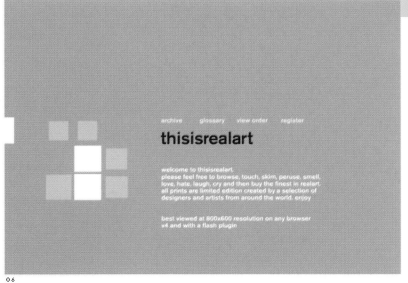

archive glossary view order register

thisisrealart

welcome to thisisrealart.
please feel free to browse, touch, skim, peruse, smell,
love, hate, laugh, cry and then buy the finest in realart.
all prints are limited edition created by a selection of
designers and artists from around the world. enjoy

best viewed at 800x600 resolution on any browser
v4 and with a flash plugin

06

(05-06)

SECOND STAGE RESEARCH

<05> The result in combining the navigational
research and the commercial necessities.

<06> The typography in this design was more
imposing than that of later versions.

THE FINAL VERSION

The homepage introduces an interface that makes the site's navigation obvious and playful.

Each square represents a piece of work. As you roll over the squares, the relevant artwork appears within the grid, helping make the site compact and easy to access. All images appear on one page, thus doing away with the need to scroll through page after page.

The relationship between text and image was appropriately balanced by stripping the typographic style down to basic forms.

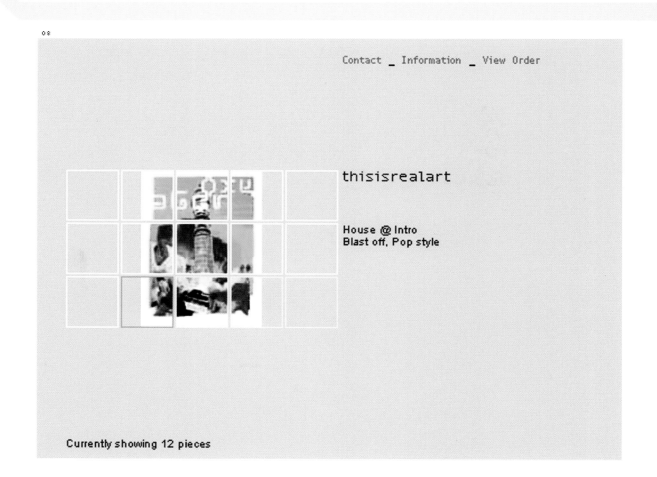

thisisrealart

Making available the art of urban culture.

Cutting edge contemporary graphic art and photography.

Limited edition prints exclusive to thisisrealart.

07

08

Contact _ Information _ View Order

thisisrealart

House @ Intro
Blast off, Pop style

Currently showing 12 pieces

thisisrealart

Kim Hiorthøy
A culture all about watching and appearing 2

Screenprint
Printed on 150gsm paper
Size (hxw): 1500mm x 1000mm
Edition of 100
1 of a series of 2
Printed by Artomatic

Price: £175 (exc VAT)

Enlarge Image _ Artist Info _ Order

09

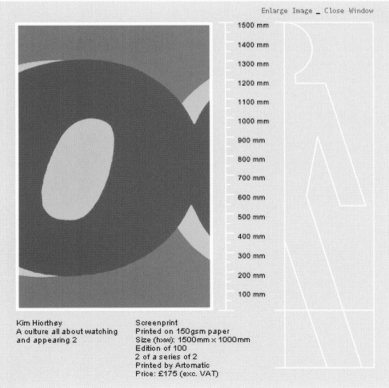

Enlarge Image _ Close Window

1500 mm
1400 mm
1300 mm
1200 mm
1100 mm
1000 mm
900 mm
800 mm
700 mm
600 mm
500 mm
400 mm
300 mm
200 mm
100 mm

Kim Hiorthøy
A culture all about watching
and appearing 2

Screenprint
Printed on 150gsm paper
Size (hxw): 1500mm x 1000mm
Edition of 100
2 of a series of 2
Printed by Artomatic
Price: £175 (exc. VAT)

<09–10>

SCALING TOOL

A common obstacle for online galleries is how to
convey the scale of works featured. thisisrealart solves
this problem by designing a simple graphic that
indicates size in relation to the human form.

10

PROJECT: HABITAT.NET
CLIENT: HABITAT
DATE: 2001
DESIGN: CHRIS BARNES,
KEVIN HELAS, MATT RICE, JON SHAW,
HEGE AABY, ADAM WILLIAMS,
STUART JACKSON
PROGRAMMING: ORLANDO MATHIAS,
THOMAS POSEUR, MIKKEL ASKJAER
ART DIRECTION: BRAD SMITH,
PRODUCTION: CLAIRE DIMELOE
TECHNOLOGY: FLASH, XML
FORMAT: WEBSITE WITH
PRODUCT SEARCH ENGINE

DIGIT

WWW.HABITAT.NET
WEBSITE/PRODUCT SEARCH ENGINE

Digit were asked to redesign and revitalise Habitat's global website, which was launched in September 2001 in five countries – the UK, Eire, France, Spain and Germany. The new site is designed to allow a seamless migration to e-commerce elements when the time comes in the future.

Digit wanted to create a fun, engaging, multifaceted web presence, that not only encapsulates but enriches the Habitat brand.

From the outset, the brief that led the design was one of 'usability and functionality'. The concept Digit adopted was simple: 'Form is Function'. This was a concept that had already been adopted by the Habitat company, and an idea that has been integral to the design of Habitat's products since Conran founded it in 1964. The website became a simple extension of these basic brand ethics.

01

<01>

SPLASH PAGE

The loading screen for Habitat uses a quirky animation of a man pulling in the Habitat logo

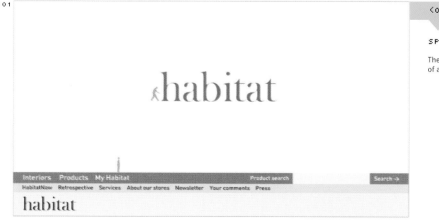

PROTOTYPE: USEFUL AS A MEANS TO EXPRESS AN IDEA AS A MODEL, OR AS A PROJECT SCENARIO.

.habitat

02

03

<02-08>

LOADING SCREENS

The new Habitat site allows the user to engage with every aspect of the site. This is immediate when logging on to Habitat. The loading screens act to both reinforce the user online experience that the site is actually loading and to give some personality to the online store.

Although the loading bars are extremely effective, they were in fact the last thing Digit thought about! Digit claim that they often work backwards, allowing graphical elements and the finer details that have been completed at deeper levels of the site to influence what the user may first see. The homepage and features like loading bars needed to reflect the rest of the site, not the other way around. If Digit were to allow the main sections of the site to be influenced by how they designed a loading bar, the site would have looked very different!

04

As with the whole site, Digit wanted the loading bars to have a human and tactile feel. They thought it was important to convey this hands-on and robust nature within the context of Habitat's calm and cool style. It's important that users understand that while Habitat sells very beautiful furniture, it's there to be used, and to live with.

05

The loading bars were a continuation of this idea. The situations that the people are in – the kitchen, the bedroom – are identifiable to everyone, even though there is no furniture present since the loading bars are the furniture. Digit chose not to show the furniture for two reasons. Firstly, file size; the illustrations of furniture doubled this. Secondly, by removing the object of importance you can make it more important! Strange but true.

07

06

Don't forget - you can print out the products that you have selected!

09

118

EXPERIENCE

Within the site, animated people appear in various situations in order to create life, intrigue, mystery and sometimes havoc with designs that without them would only be beautiful. Digit wanted the viewer to not only appreciate the Habitat experience but to touch it.

The Habitat experience is furthered by splitting the site's interior section into three environments of Habitat: Chic ⟨09⟩, Luxury ⟨10⟩ and Useful. The site is brought to life with the use of natural sounds and contemporary music, and ghost figures walk onto the screen and through the rooms.

The Chic, Luxury and Useful themes were originally devised by the internal design and marketing teams at Habitat as a starting point for their own furniture design. This theme was then expanded by Digit to capture the mood and tone of that furniture.

INSPIRATION

The site design was inspired by a scene from the film 'Fight Club', where Ed Norton walks through his apartment. As he meanders through, he describes the various objects that he's bought from a furniture catalogue. The camera pans around the apartment, and typography with the name and price of each object appear. This relationship bridged the gap between the 'real' and the 'virtual' perfectly. So Digit set about designing a 'space' in which the user could move around various room sets, and as the user rolled over any object within that room, the name and price would be revealed. For example, 'Day's Forum £1199' and 'Jaq £89'.

<11–13>

ICONS FOR SITE NAVIGATION

The design of the products section uses simple silhouettes to indicate sub-categories <11>. By choosing one we can go deeper into that sub-section <12>. The Home Office route ends in photographed furniture, prices and specifications <13>.

MAINTENANCE

The design reflected a need for regular updates, managed by the designers. Another key factor in influencing the initial design concepts was 'flexibility'. The site produced had to be flexible enough to embrace the almost bi-monthly seasonal product changes. With every season comes hundreds of new products, along with new colour palettes, new catalogue photography, new in-store graphics and other external print work.

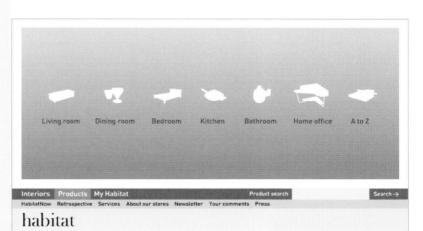

11

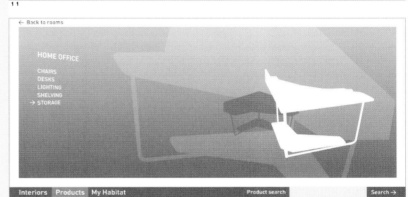

12

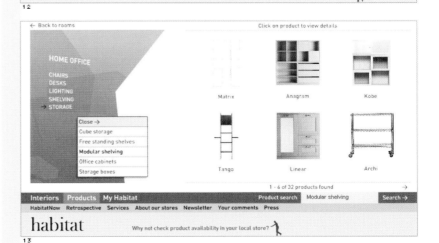

13

DESCRIPTION

PROJECT: MICROPHONE FIEND
ACADEMIC WORK:
PRODUCT VERSION PUBLISHED
DIGITALOGUE 1999 FROM STUDENT
VERSION PUBLISHED RCACRD, 1996
DATE: 1996-1999
PRODUCT, DESIGN AND
PROGRAMMING: TOTA HASEGAWA
TECHNOLOGY: DIRECTOR MOVIE
FORMAT: CD-ROM
WEBSITE URL: WWW.TOTA.NE.JP

TOTA HASEGAWA

MICROPHONE FIEND
CD-ROM/INSTALLATION

Microphone Fiend challenges designers to look beyond the mouse as an input device for interaction. It consists of a series of experimental pieces exploring the idea of analogue interaction, using a microphone as an input device. This new space questions the role of interaction between user and information. The work is inspiring for its immediacy and sense of fun.

Microphone Fiend is an interactive CD-ROM that consists of 12 different games using a microphone as the input device. The idea behind the project was to create an interactive multimedia CD-ROM where the main content was not based on narrative (or story) but interaction itself. This project allowed Tota to explore what makes interaction design both engaging and entertaining.

The sub-theme of this project is to provide humour through interaction design. It is designed to be nonsensical (as an element of humour) and it is designed to leave space for the user to make their own interpretation of the story – there isn't any particular background story.

Each game is based on a simple interaction system based on microphone input. They require the user to blow the microphone and use a few mouse clicks to go through the games.

<01>

INSTALLATION

A monitor is housed in a telephone booth, as sound-reactive work always works badly in noisy spaces. As a display piece, the work uses a blowing device instead of using a standard microphone input.

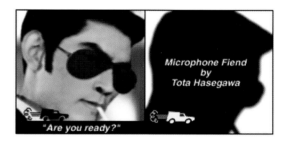

02

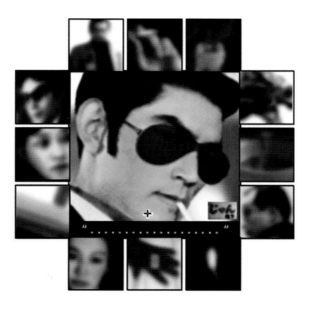

<02>

NAVIGATION

After installing and launching Microphone Fiend, the user is forced to blow the microphone from the start. The interface can only be activated by blowing into the microphone – each blow will reveal more and more of the screen until finally the user is shown a complete interface within which to play. The navigation for Microphone Fiend is centred around the character in the middle of the screen who acts as your guide to the CD-ROM.

BLOWING EXPERIMENTS

These pictures refer to each experiment requiring you
to blow on the microphone. Each experiment deals
with how an image can be individually viewed and
played. ⟨O3⟩ The more the user blows, the foggier
the screen becomes. The mouse can then be used to
wipe away the mist. ⟨O4⟩ A man exhales smoke from
a cigarette. The more the user blows, the more the
screen becomes smoky, until the man starts to cough.
Other methods include playing frames from an old
movie ⟨O5⟩ and blowing out a lit match.

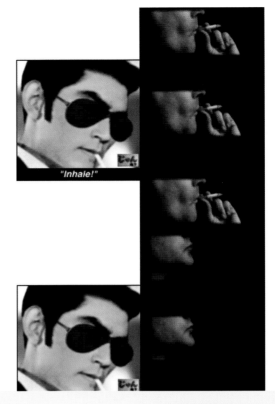

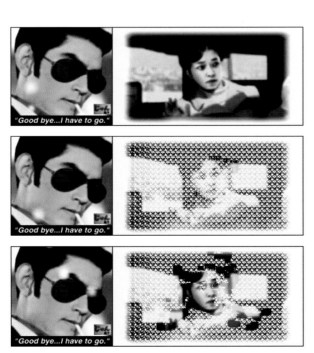

03

04

"Don't miss the target!"

"Don't miss the target!"

"Don't miss the target!"

"Don't miss the target!"

"Don't miss the target!"

"Don't miss the target!"

05

"Do you want to quit?"

"Do you want to quit?"

"Do you want to quit?"

06

123

INTERACTIVE

DESCRIPTION

PROJECT: ONEDOTZERO
CROSS-PLATFORM IDENTITY
CLIENT: ONEDOTZERO
DATE: 1997-PRESENT
DESIGN, ANIMATION AND
PROGRAMMING: STATE DESIGN
MUSIC: NICK RYAN
TECHNOLOGY: AFTER EFFECTS,
DIRECTOR SHOCKWAVE, INFINI-D,
LIGHTWAVE, QUARK, FREEHAND,
ILLUSTRATOR, PHOTOSHOP, FLASH
FORMAT: WEBSITE, CATALOGUE,
TV TRAILER

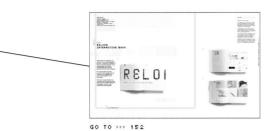

GO TO >>> 152

124

STATE

ONEDOTZERO
WEBSITE/PRINT/ONSCREEN

onedotzero is a touring festival of digital moving image in the UK. For the past five years, State have created all visual material for the festival, both on screen and in print.

The basic elements of onedotzero's identity are a simple logotype and typeface. These two elements, together with a changing annual theme (related to the curatorial aims of the festival), form the festival's identity.

The theme is usually quite a loose avenue of enquiry that allows a large amount of freedom of expression in individual applications.

The first three years of the festival saw quite a consistent, rigorous exploration of the idea of 'frame' in the context of digital film. This idea was explored in print, online and onscreen.

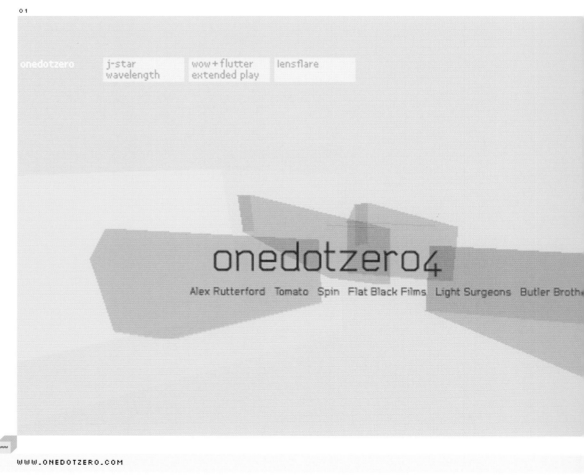

WWW.ONEDOTZERO.COM

SEARCH ENGINE: ALLOWS THE INPUT OF KEY WORDS IN RELATION TO INFORMATION YOU ARE LOOKING FOR, WITH WHICH IT CAN SEARCH ITS OWN DATABASE OR OTHER SEARCH ENGINES TO PROVIDE FEEDBACK.

02

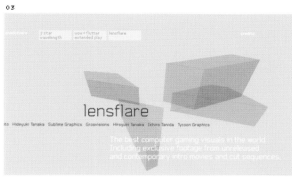

j-star/wavelength

ONEDOTZERO4 WEBSITE, 2001

The three-dimensional blocks that feature on these navigational pages are kinetic, revealing information as they turn on their axes. Their movement has a filmic quality. J-star, Lensflare and wow+flutter are mini film festivals that function under the umbrella of onedotzero. As the blocks revolve, the mini film festival information is revealed. 〈02–05〉

onedotzero4's identity for 2001 was the city. Due to download times, the blocks are simplified representations of forms found in cityscapes.

03

lensflare

125

04

wow+flutter/extended play

05

wow+flutter/extended play

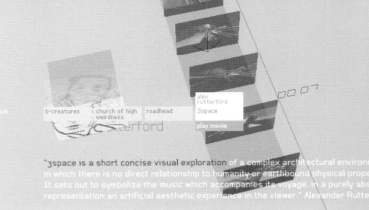

"3space is a short concise visual exploration of a complex architectural environm
in which there is no direct relationship to humanity or earthbound physical proper
It sets out to symbolize the music which accompanies its voyage, in a purely abst
representation an artificial aesthetic experience in the viewer." Alexander Rutter

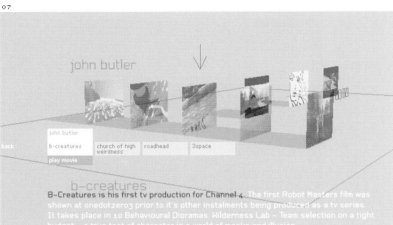

B-Creatures is his first tv production for Channel 4. The first Robot Masters film was
shown at onedotzero03 prior to it's other instalments being produced as a tv series.
It takes place in 10 Behavioural Dioramas. Wilderness Lab – Team selection on a tight
budget – a true test of character in a world of masks and illusion.

‹06-08›

INTERACTIVE FILM CLIPS

Highly innovative, easy-to-use interfaces present
films as flat strips of images, so you can 'read the film',
and start playing the film from any point – without
having to use traditional transport controls such as
playback buttons copied from standard tapedecks
or web players.

In this interactive three-dimensional environment, film
clips are represented by single frames; when clicked,
the frames cascade open, so information about each
artist is ready to view.

‹09›

MOUSE INTERACTION

By moving the mouse, the viewing angle can be varied.

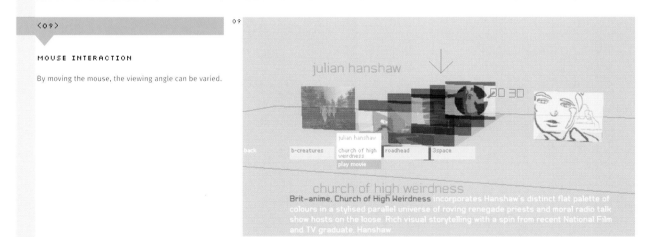

church of high weirdness

Brit-anime. Church of High Weirdness incorporates Hanshaw's distinct flat palette of
colours in a stylised parallel universe of roving renegade priests and moral radio talk
show hosts on the loose. Rich visual storytelling with a spin from recent National Film
and TV graduate, Hanshaw.

〈10–12〉

INTERACTIVE PRINT

Alternate ways of presenting the video frame onscreen and in print are explored through the theme for each festival. The motion of film is transported into the print medium by the careful use of material, paper stock and format. Instead of simply translating the website into print, the design echoes the site's feeling of interaction by using multiple images of the same object shown at slightly different angles to give the sense of a flickering movie.

State created the identity for onedotzero4 so that it could be delivered in both traditional and new media applications. This means the percentaged images of cityscapes and urban flyovers continue that year's theme of the city.

13–18 november 2000

onedotzero_berlin.
digital film festival aus london im
rahmen der. uk art 2000 saison in
berlin–mitte und in zusammenarbeit
mit the british council

www.onedotzero.com
www.britishcouncil.de
www.sonarkollektiv.com

The British Council CENTRAL STAATSBANK FRANZOESISCHE STRASSE ICA

⟨13-26⟩

TELEVISION TRAILER

The onedotzero identity is applied successfully to any medium. The television trailer combines the high-resolution graphics of the print-based work with the filmic sense of the website's navigation.

SOUND TOYS: SOUND/AUDIO APPLICATIONS DESIGNED TO ENHANCE THE USER EXPERIENCE
OF INTERACTING WITH SOUND. THEY ARE USUALLY SMALL APPLICATIONS THAT CAN BE PLAYED OVER THE INTERNET.

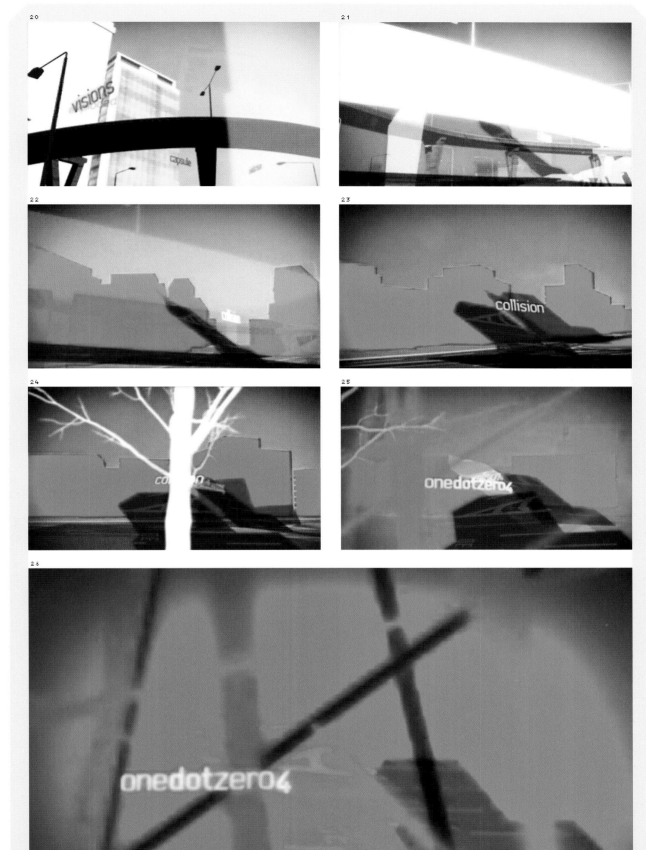

INFLUENCE

INFLUENCE
DIGITAL REFLECTIONS IN PRINT DESIGN

Some people are sceptical of the march of new media. There have been many comments within the wider design community that technology has caused designers to forget their role in favour of jumping on the latest software bandwagon – choosing the easy look of a Photoshop Filter over a technique they have created or made their own. It is becoming easier and easier for designers to remain locked within their computer environment and to not step outside or seek influences from other media and other ways of working.

A recent escalator advert that I saw on the London Underground is an interesting example of the way design can break out of its own frame of reference. The advert, for printer company Epson, featured five A3 posters which read 'Epson'. However, the letters were so pixellated that they could only just be made out. I noticed that people were looking and trying hard to make out what it all meant. Without the pixellated monitor, such ideas would not be possible, so here we see technology influencing the visible message, creating a feedback loop between one technology (digital) and another (print).

A variety of visual aids have long been in existence for the print designer to take advantage of – picture libraries and common decorative motifs, for example – and the increasing use of digital technologies has seen these aids multiply and become accessible to greater numbers of people, both designers and non-designers alike. But rather than being inspirational, they take advantage of the designer having to work to short deadlines. The driving force behind many such technologies is that their designers try their hardest to recreate digitally the physical appearance of lithography and printing. Too often the pressure of deadlines means that designers become constrained by their tools, relying on the ease of ready-made solutions instead of developing their own.

In print, designers live in a world of CMYK (cyan, magenta, yellow and black), striving to capture the natural essence of colours, hue and shade. Printer's ink has its own qualities, and the ability to play with and blend colour is an art in itself. The real world is matched with the dots of the virtual world and colour charts are held up to real objects to make exact colour matches when printed. One of the projects profiled here, Image Bin, is a startling attempt to narrow the gap between the methods of production found in silkscreen printing and the design and programming of software applications.

Most new media designers are not aware of the material. They don't need to be aware of it, since their final design output will most probably be software-driven, rather than a material object. Image Bin highlights comparative methods of programming HTML, Lingo and DHTML and printing methods – lithography, silkscreen, and foil blocking.

The word 'screen' in silkscreen printing refers to the method by which we make contact between our image and the paper or fabric it is being printed on. The word 'screen' in new media refers to the physical display, the unchanging monitor – the two spaces are different, but not exclusive. Experimenting with how images and text are displayed in new media is just as important as in print. For the traditional graphic designer, silkscreen printing is a method of making multiples of graphic posters. For the internet designer, the monitor can also be treated with similar values. Physical and virtual, they are all screens in which messages are read.

This chapter is not a conclusion to the book, but a space in which to reflect on the relationship that can be made between internet and paper technologies. As designers strive for an understanding of our physical and virtual surroundings, those who are able to bridge these gaps will influence whole new generations of designers and the ways in which information is communicated. All of the designers who are featured here work in digital media but have come from a print background. Each has embraced the new digital technologies and their possibilities. The chapter could almost be the start of another book – the work here helps us to understand what effects technology has on a graphic visual culture, how technology informs and influences us and how we come to rethink our attitudes to the way a book is constructed or what deems a typeface to be made and produced.

Designers have long recognised the need to introduce new printing methods and packaging formats, attempting to highlight that reading should be seen as an interactive experience. This experience could be compared with designers in new media who constantly try to reinvent new paradigms: new means of expression through programming, designing applications and graphic interfaces, etc.

IT IS BECOMING EASIER AND EASIER FOR
DESIGNERS TO REMAIN LOCKED WITHIN THEIR
COMPUTER ENVIRONMENT AND TO NOT STEP
OUTSIDE OR SEEK INFLUENCES FROM OTHER
MEDIA AND OTHER WAYS OF WORKING.

Electronic publishing has witnessed the arrival and design of many electronic devices that can display text and image as well as browse the internet and send email. Handheld devices such as the Palm allow the user to download an entire novel or short story from their PC and read it anytime, anywhere. But it is important to question the need for such a device when a novel does the same thing as a portable object. Are we just looking for new gadgets to replay the same message?

Widespread access to new and unpublished material is one of the key problems that faces book publishing. In the Diffusion e-books series, the internet itself acts as a publishing house and distribution network. Uniquely, the e-books are designed in the same way as a traditional book, with pagination and crop marks, but they are not printed in the traditional way – they are downloaded to the user's desktop. They are not designed to be viewed on screen. These books are for printing out and constructing your own volume. Distribution of this is global; anyone can download and make their own book, no glue is required, or special software, since it uses Adobe's ubiquitous PDF format. It connects people to the idea that the internet can also be physical, and can be used in interesting ways.

Computers were originally designed to help with big formulae, 'crunching' mathematical data. Their role of making tasks easier and more manageable takes an interesting turn in the LettError Interactive book – LettError's designers abandoned the use of QuarkXPress in favour of building and programming a machine that would act in the decision-making process of designing a page – how an image would appear, the choice of typeface, etc.

The sampling of computer code is also witnessed in the work of David Carson. In his experimental design work for RayGun, he set whole interviews with musicians in the font Dingbats. He was attempting to express his concerns that people didn't read any more and was inspired to challenge the conventions of readability of text by applying this symbol typeface.

The use of programming as a production tool for making ideas viable is seen in two different ways in this chapter: Chinese Whispers explores how a typeface can be constructed and designed in an entirely new way. Typography used to be seen as an élite profession, with only skilled craftspeople able to produce typefaces.

The arrival of desktop typographic applications meant that anyone could design and publish their own typefaces. Chinese Whispers has itself developed typeface design and production a stage further. In the same way that chat rooms have rapidly brought groups of people together, Chinese Whispers is a community platform for typographic expression, where designers and non designers are invited to contribute to the development of a typeface family.

In the Container/navigation project, its designers begin to examine what internet navigation might look like in the material world. By making a book and sewing the needle and thread through it, they allow the visual idea of networks to be shown. Actual networks are abstract and hard to visualise – this book gives the reader a feel for the navigation, its possible fragility and for the experience of weaving their way through it.

The photocopier gave designers another tool to develop expression with, but it didn't influence the way in which we communicate visually. However, it is possible that it allowed the idea of what was being communicated to be deconstructed and taken into new spaces. The photocopier's lo-fi grain has clearly influenced designers like Anthony Burrill and Christian Küsters, who find influence, usability and beauty in the pixel grain. They both abstract the pixellated image and form it into something individual, which helps to convey their visual graphic statements.

This chapter demonstrates the immense breadth of creativity that drawing from a diverse stable of influences can bring. That some of the most exciting designers working in internet design today have come from a print background should inspire us all to continue to innovate and apply radical design solutions from one discipline to another. That way a freshness and edge can be maintained, at the same time as bringing visible benefits to clients.

DESCRIPTION

PROJECT: DIFFUSION E-BOOKS
CLIENT: PROBOSCIS
DATE: 1999-ONGOING
DESIGN AND PRODUCTION:
NIMA FALATOORI AND
PAUL FARRINGTON
TECHNOLOGY: QUARKXPRESS,
FREEHAND, HTML, ADOBE ACROBAT
FORMAT: INTERACTIVE E-BOOKS FOR
PRINT, DOWNLOADABLE PDF FILES

NIMA FALATOORI AND PAUL FARRINGTON

DIFFUSION E-BOOKS
DIGITAL PUBLISHING

E-books were big news in 1999 and 2000, with large web portals selling them being set up by major companies like Barnes & Noble in the US. Once again, the end of print was trumpeted as it was assumed readers would abandon paper books in favour of e-book readers. But why abandon more than 500 years of print design simply to satisfy a brief fad for executive toys?

The internet provides a radical platform for small presses to reach parts of the world that it would not be economical to distribute traditional books to. By making the e-book files free to download and redistribute as well as small in size, the publisher ensures that the knowledge contained in the books will reach a far greater audience than was previously accessible.

Diffusion e-books are designed to be output both as PDF (portable document format) books and as high-resolution printable books. The format marks a stage where the print designer can make accessible new forms of distribution by using cross-media solutions.

STREAMING: WE CAN DOWNLOAD FILMS AND MUSIC FROM THE INTERNET, BUT SLOW INTERNET CONNECTIONS AND LONG DOWNLOAD TIMES PUT USERS OFF DOWNLOADING LARGE FILES. STREAMING ENABLES SMALL SECTIONS OF A DATA FEED TO BE DOWNLOADED AND ACCESSED FOR PLAYBACK IN STAGES – AND THEREFORE PLAYS THE DATA WHILE DOWNLOADING.

01

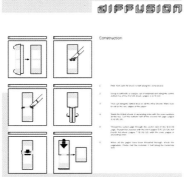

Construction

02

THE ISLAND BELL

KATHARINE MEYNELL

03

04

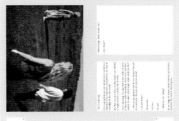

05

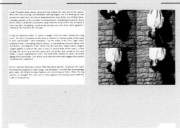

06

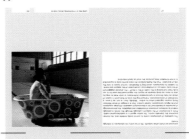

Dragan Zivadinov's *Noordung Cosmokinetic Cabinet Theatre* or to be blind in the Cosmos, seeing through text

<01–06>

DESIGN OF AN ARTIST'S BOOK

The Diffusion e-book format designed for Proboscis questions the role of the publisher, the author and the reader. The e-books are a series of online 'books' made available for download as PDFs from the website. The user/reader then prints out and constructs their own paper book from instructions supplied. In this way, small books (typically containing a single illustrated essay) or 'artist's books' can be published and distributed digitally worldwide.

DISTRIBUTION

Diffusion e-books are PDF files designed to be downloaded, printed out and made into booklets by the reader – a simple and effective mode of publishing that bypasses many of the problems encountered by small presses and specialist publishers. The Diffusion format challenges conventions of interactivity – blending the physical and the virtual and breaking the dominance of mouse and screen as the primary forms of human/computer interaction. The format's aim was to take the reader away from the screen and computer and engage them in the process of production – the physical act of making the e-book – creating a different dynamic between producer and consumer of knowledge and information.

Diffusion e-books are free to download and distribute, electronically or as material objects. The format is 'open source', ie, Proboscis welcomes the adoption or reinterpretation of the format by anyone, anywhere.

135

INTERACTIVE THE INTERNET FOR GRAPHIC DESIGNERS

DESCRIPTION

PROJECT: CHINESE WHISPERS
CLIENT: BEAUFONTS/TECHNOCULTURE
DATE: 2000-2001
PRODUCTION AND DESIGN:
IAN MITCHELL, SUPPORTED AND
FUNDED BY THE LIVERPOOL SCHOOL
OF ART AND DESIGN RESEARCH GROUP
TECHNOLOGY: DIRECTOR
SHOCKWAVE, HTML
FORMAT: WEBSITE

01

<01>

SPLASH PAGE

Information graphic from Chinese Whispers homepage
showing how the system works: log on to the internet,
draw a character, submit to Beaufonts and then
download the finished font.

IAN MITCHELL

CHINESE WHISPERS
COLLABORATIVE FONTS

<02>

CATALOGUE

A page from the Chinese Whispers catalogue
showing the first font experiment of Woodblock
from Outer Space initiated by Erik van Blokland.

The Chinese Whispers project is
an online experiment in creating
collaborative fonts, allowing anyone
from around the world with access
to the internet to respond to, and
contribute to, a set of ever-evolving
typefaces. The project was launched
with five typographic 'whispers',
characters created by designers Erik
Van Blokland, Tobias Frere-Jones,
Jonathan Hitchen, David Crow and
Yaki Molcho. These were posted
on a project website where others,
using the specially developed
LetterFormer™ software, could
use them as the basis to create the
next letter in the alphabet until a
complete set of characters had
been designed. In total, more than
180 people from 23 countries
around the world contributed to
the project. Initial results were
documented in a 32-page print
catalogue, containing examples
of the characters and letterforms
generated, a full list of contributors
and some basic empirical analysis of
the development and characteristics
of each fonts.

02

› (EXP1.1)

› a → z A → z 1 → 0

a b c d e f g h i j k l m
n o p q r s t u v w x y z
A B C D E F G H I J K L M
N O P Q R S T U V W X Y Z
1 2 3 4 5 6 7 8 9 0

› character contributor_if_known (source_if_known)

a Erik van Blokland (Netherlands) › b Toby (UK) › c David Crow (UK) › d Owen (_) › e Hitch (UK) › f Darragh Nolan (Ireland)
› g Doug Kerr (UK) › h Hitch (UK) › i J Luber (USA) › j Paulo Barnesi (_) › k Henrik Karlsson (Sweden) › l Hitch (UK) › m
Matteo Bologna (USA) › n Hitch (UK) › o Andy White (UK) › p Andy White (UK) › q Andy White (UK) › r Andy White (UK) › s Andy
White (UK) › t Stephen Coles (USA) › u Oliver Payne (UK) › v Dmg (Germany) › w asdfasa (_) › x Hitch (UK) › y Glen Crawforth
(UK) › z Ian Mitchell (UK) › A Mark Astle (UK) › B Oliver Payne (UK) › C Dmg (Germany) › D Grant Hutchinson (Canada) › E
Grant Hutchinson (Canada) › F Dfas (_) › G Davin Risk (Canada) › H Davin Risk (Canada) › I Brian Levy (USA) › J Karawynn
Long (_) › K Micah Lawler (USA) › L Brian Levy (USA) › M Brian Levy (USA) › N Brian Levy (USA) › O Brian Levy (USA) › P
Pamela Robbins Mccarty (USA) › Q Cory (Canada) › R ghetto@dope.com (_) › S Brian levy (USA) › T Micah lawler (USA) › U
Dan Heinzkill (USA) › V Dan Heinzkill (USA) › W Biologic (New Zealand) › X Annabel Frearson (UK) › Y Mishx (_) › Z Brian Levy
(USA) › 1 S Askew (_) › 2 Ian Mitchell (UK) › 3 David Gibson (UK) › 4 Hitch (UK) › 5 Matt Jastremski (_) › 6 Brian Levy
(USA) › 7 David Gibson (UK) › 8 Keri Andrews (UK) › 9 Hitch (UK) › 0 Brian Levy (USA) → 0 Matt Heximer (Canada)

STREAMING MEDIA: STREAMING IS DESIGNED SO THAT THE USER IS ABLE TO SEE OR HEAR A FILE AS IT IS BEING DOWNLOADED. RATHER THAN
NEEDING THE ENTIRE FILE, THE COMPUTER IS ABLE TO ACCESS PARTS OF THE FILE AS IT IS ARRIVING. REALPLAYER, QUICKTIME AND WINDOWS
MEDIA ARE THE COMMON STREAMING APPLICATIONS AVAILABLE, AS WELL AS INTERACTIVE STREAMING IN FLASH AND DIRECTOR SHOCKWAVE.

03

> DESIGN TEMPLATE: LOWERCASE LETTER 'a'

-> SUBMIT TEMPLATE: 'a'

© 2000-2001 BEAUFONTS

04

> DESIGN TEMPLATE: LOWERCASE LETTER 'a'

-> SUBMIT TEMPLATE: 'a'

© 2000-2001 BEAUFONTS

05

> DESIGN TEMPLATE: LOWERCASE LETTER 'a'

-> SUBMIT TEMPLATE: 'a'

© 2000-2001 BEAUFONTS

<03-05>

USER EXPERIENCE

<03-05> The user finds the shadow of the previous letter in the alphabet when coming to design the next. The completed design is submitted and then becomes the shadow left for the following user. Once the alphabet has all 26 characters, the font is selected and published as a download online. The typefaces are available in the standard Truetype or Postscript Type 1 format for Mac and PC.

SOFTWARE TOOLS

The system is based around LetterFormer™, a shockwave application built in Director. The software, when embedded in a webpage, allows participants of the project to design and submit characters online.

DESIGNING LETTERFORMS

To design a letterform, users must link together modular shapes on a 10 x 12 grid. The shapes were initially grouped into seven sets or types; basic, curve, counter, diagonal, apex, join and cap, to make choosing one more manageable. These terms are specific to this project and don't necessarily correlate to the more traditional terms for defining typographic elements. The shapes could be used in whichever way was felt appropriate.

They were designed to give the user the ability to create a wide variety of letterforms ranging from the traditional to the more experimental. Additional shapes have since been added in response to some of the limitations of the original system. New shapes include a set of bitmaps, more joins and an extra degree of diagonals. Once a character has been designed, it can be sent to a database on the website's server. In reality it isn't the shape or outline of the character that is sent, but a list of 120 numbers that represent the different shapes on the grid that make up the character. These lists of numbers can then be converted back to letterforms whenever necessary.

137

INTERACTIVE THE INTERNET FOR GRAPHIC DESIGNERS

"Most typefaces are logically systematic. If you see a few letters you can pretty much guess what the rest of the font will look like."

07

"Our sensibility — that is our visual perception and our aesthetic sense — is superior to geometric construction... the typeface which looks 'right' to the eye, a human organ, cannot be constructed."

(06-09)

CHINESE WHISPERS CATALOGUE

The catalogue offers detailed information and background research into the Chinese Whispers experience.

08

09

TESTING: AS THE INTERNET IS A CROSS-PLATFORM SYSTEM, DEVELOPERS NEED TO TEST THEIR DESIGNS ON A VARIETY OF MACHINES AND BROWSERS SO THAT THE FINAL SITE CAN BE VIEWED BY ANYONE, ANYWHERE.

<10>

An enormous variety of letterforms were produced.
This example in the background features a selection.

11

EXPERIMENT 1: WOODTYPE FROM OUTER SPACE (restricted shapes)
INITIATED BY ERIK VAN BLOKLAND (NETHERLANDS)

VERSIONS:	FOR MAC:	FOR PC:	CONTRIBUTORS:
WOODTYPE FROM OUTER SPACE (EDITED)	+- 20K	+- 16K	-
WHISPER-EXP1R1	-	-	-
WHISPER-EXP1R2	-	-	-

12

EXPERIMENT 4: FLUID WOODBLOCK
INITIATED BY DAVID CROW (UK)

VERSIONS:	FOR MAC:	FOR PC:	CONTRIBUTORS:
FLUID WOODBLOCK (EDITED)	+- 24K	+- 16K	-
WHISPER-EXP4R1	-	-	-
WHISPER-EXP4R2	-	-	-

13

EXPERIMENT 2: HALF BAKED, HALF UNCIAL
INITIATED BY TOBIAS FRERE-JONES (USA)

VERSIONS:	FOR MAC:	FOR PC:	CONTRIBUTORS:
HALF BAKED, HALF UNCIAL (EDITED)	+- 20K	+- 11K	-
WHISPER-EXP2R1	-	-	-
WHISPER-EXP2R2	-	-	-

14

EXPERIMENT 5: ALEF (Hebrew starting point)
INITIATED BY YAKI MOLCHO (ISRAEL)

VERSIONS:	FOR MAC:	FOR PC:	CONTRIBUTORS:
ALEF (EDITED)	+- 20K	+- 12K	-
WHISPER-EXP5R1	-	-	-

15

EXPERIMENT 3: MENTALIST STENCILIST (restricted shapes)
INITIATED BY JONATHAN HITCHEN (UK)

VERSIONS:	FOR MAC:	FOR PC:	CONTRIBUTORS:
MENTALIST STENCILIST (EDITED)	+- 20K	+- 11K	-
WHISPER-EXP3R1	-	-	-
WHISPER-EXP3R2	-	-	-

<11-15>

FINAL FONTS

Each completed typeface featured, including
Woodtype from Outer Space <11>, Fluid Woodblock
<12>, Half-baked, Half-uncial <13>, Alef <14> and
Mentalist Stencilist <15>, is available as a download
from the project website.

DESCRIPTION

PROJECT: THE LETTERROR BOOK
CLIENT: CHARLES NYPELS
FOUNDATION AND PUBLISHER
DATE: JUNE-OCTOBER 2000
DESIGN AND PROGRAMMING: JUST
VAN ROSSUM AND ERIK VAN BLOKLAND
PRODUCTION: JO FRENKEN AND
ELS KUIPERS AT THE JAN VAN EYCK
ACADEMY, MAASTRICHT
PRINTING: DRUKKERIJ ROSBEEK
TECHNOLOGY: XML AND POSTSCRIPT
FORMAT: BOOK
WEBSITE URL:
WWW.LETTERROR.COM/CONTENT/NYPELS

140

INFLUENCE

LETTERROR

THE LETTERROR BOOK
PROGRAMMING AND PAGINATION

The Charles Nypels Foundation chose to give their 2000 award to Dutch designers LettError. Part of the award was the request to design and produce a booklet about their work.

Instead of simply using conventional design tools such as QuarkXpress and DTP applications, LettError decided to express their ideas about typography, programming and design by engineering software that would explore a new way to design a book, and to take care of the process. LettError, in effect, created a book machine. The system built does not 'design' the book per se, but it does everything else. Image positions, typography, fonts, colour, imagery and animations are all interlinked and dynamic. This dynamic process has its own self-generating system, so that decisions about the placement of images, text and other graphic elements are reached automatically.

Random parameters were programmed in order to introduce a 'human' element into the book's production, causing some details in the book to be different each time it was generated. The book that was printed is one of many possibilities.

As both LettError designers work in separate locations in the Netherlands, it was important that the designers could access up-to-date versions of all files. To make this work as smoothly as possible they used a tool from the programmers' world: Concurrent Versions System or CVS. The computers connect via the internet to the CVS server containing all the information. The server also keeps a history of all changes to each document.

TIFF: A PRINT GRAPHIC FILE FORMAT.

(01-02)

LETTERROR INTERACTIVE BOOK

Detail of pages showing the variety of creative experiments in LettError's work.

03

04

(03-05)

LETTERROR INTERACTIVE BOOK

<03> Front cover.

<04> Certain pages have animations revealed as the book's pages are flicked through.

<05> The right-hand edges of the book have LettError printed on them. This feature enhances the interactive nature of this work. The red pixel lines are a slice of the word LettError.

PROGRAMMING AND PRODUCTION

05

By building the book machine, LettError changed the divide between design and production. The design took form from code programmed to vary the tasks necessary to book design.

Dynamic relationships form between various items on the page and between pages themselves. Each object on the page depends on hard parameters, like the body size of the text, or the number of pages.

Some random parameters were also included so that odd details in the book changed with each new generation. This meant that each book printed was one of many possibilities.

<06-11>

TOOLS AND METHODS

Detail of pages showing the variety of creative experiments in LettError's work.

The book machine represents all of LettError's design decisions, allowing them to make sweeping changes right up to the last minute. The changes work their way right through, altering all the items on each page as the elements respond, as programmed, to new, altered parameters. The book machine became the tool to generate the book and it took care of production issues as well, for example causing illustrations to bleed when placed on the cutting edge of a page.

It would have been possible to make the book using conventional methods, but it would have looked different, taken more time, and not been as much fun to make. The project's design frame took influence from the programmer's palette. The book in both its visual form and in its production are questioned and the LettError book creates new standards for book design.

06

07

08

In Serge
you will
that he
that on
it was a
up to or
statemer
that she
after sh
in the b

09

OVER A
MILLIC
Dennis
Romance
in the las
Eminent Cr
in the s
DU
EDGA
W.M.
Bran
H.G
Jule
"Public Th
— Torquema
His work
THE BR
The Titles
THE FORB
CONT
THEY FO

t Page's evi
have observed
tates very de
aturday the l
lovely mornin
o' clock. In
to us we hav
re-read the l
had parked h
n which was

PHoTOS
1934 LiCeNSE PLAtES
PrOCURED HERE
also LiCeNSE PhotO STUDio
In 5 min.
AUTO LiCeNSE AppLICAtIoNS
FILLEd OUt & SWORN TO
nOtARY PuBLiC

UARTER OF A
COPIES OF
Wheatley's
have been sold
twelve months!
s have placed him
me class as:
MAS
WALLACE
e Queux
Stoker
Wells
s Verne
ller-Writer Nº 1"
a in the Observer
published in
ISH EMPIRE
f His Books Are:
DEN TERRITORY
ABAND
ND ATLANTIS

Cast iron, however, if subjected to only one single fusion, is rarely sufficiently homogeneous; and it requires a second fusion completely to refine it by dispossessing it of its last earthly deposits. So long before being forwarded to Tampa Town, the iron ore, molten in the great furnaces of Coldspring, and brought into contact with coal and silicium heated to a high temperature, was carburized and transformed into cast iron. After this first operation, the metal was sent on to Stones Hill. They had,

DESCRIPTION

PROJECT TITLE: IMAGE BIN
BRIEF: SELF-INITIATED
DATE: ONGOING
DESIGN AND PROGRAMMING:
JONATHAN HITCHEN,
A BEAUFONTS PRODUCTION
TECHNOLOGY: DIRECTOR
SHOCKWAVE, HTML
FORMAT: WEBSITE AND
DOWNLOADABLE PROJECTOR

144

INFLUENCE

HITCH

IMAGE BIN
DIGITAL SILKSCREEN

Although all of the other projects in this chapter take influence from digital technology and the internet, this project takes influence from silkscreen printing. Its inclusion is aimed at encouraging consideration of image-making and other methods of creating images, and the importance of sometimes concentrating on the process rather than the result.

Image Bin simulates the process of silkscreen printmaking in which multicoloured images are created from a series of simple monochrome starting points. Rather than just imitating the flat colour and hard edges that tend to characterise the appearance of a silkscreen print, Image Bin offers a custom-built space in which to explore the use of separations to make images.

Printmaking is concerned with the creative reproduction of image and text, often using technology that is considered obsolete by today's standards of mass reproduction. It is very much about exploring the delicate aesthetic relationship between personal expression and the constraints of a specific technical procedure. Image Bin was designed with this definition of printmaking in mind.

Large-scale reproduction of a colour image is, generally speaking, a highly automated and standardised process that begins by separating an image into the primary components of cyan, magenta, yellow and black (via scanning) and ends by reassembling these separations with coloured ink (via printing).

The enjoyment of silkscreen printing is in the layering of images and colour. Unsurprisingly, most image-editing software supports this CMYK-centric view of the printed image, and though these tools can often be configured for increasingly diverse and complex uses, the multitude of colours outside of the basic four-colour set are paradoxically treated as special. Image Bin treats all colours the same.

www

TIME-BASED MEDIA: THIS IS SIMPLY MEDIA THAT INVOLVES TIME AND THEREFORE HAS A
BEGINNING AND END — OBVIOUS EXAMPLES BEING FILM AND MUSIC.

<01>

IMAGE BIN PRINT

An example of the 72dpi texture found
from an Image Bin print.

<02-05>

DIGITAL PRINT

Exercises that demonstrate the layering of images.

145

INTERACTIVE THE INTERNET FOR GRAPHIC DESIGNERS

<07>

IMAGE BIN PRINT

An example of the 72dpi texture found
from an Image Bin print.

06

| jo 11.pct |
| jo 05.pct |
| jo 02.pct |
| jo 05.pct |
| GROUND |

INFLUENCE

148

<06>

MIXING DESK APPLICATION

<06> From a functional point of view, Image Bin is
based around the starting point of an audio mixing
desk. Each channel (or layer) contains its own set of
tools that relate to one component of the overall
image. Up to five black and white separations can be
layered on top of one another. Each separation can be
individually coloured, repositioned and manipulated in
a variety of ways. Since the original separations are
never altered, the editing process is non-destructive.
A large range of variations can be previewed very
quickly and this often leads to unexpected
combinations.

The Image Bin process is about exploring and
capitalising on a series of aesthetic limitations.
First of all, it works with 72dpi images, and these
lo-fi starting points largely determine the visual
aesthetic of the final outcome. The constraints of
programming contribute to this aesthetic, especially
when the tools are pushed to their extremes.
The limitations of Director 7 as an image editor
must also be taken into account.

TAILORED WORKSPACE

The workspace itself has been designed to avoid
the ergonomic shortcomings of much mass-market
software – tools that are built with work very much in
mind. The luxury of a custom workspace is that it can
be tailored to the whims of a designer tired of using
someone else's tools.

The process of using Image Bin is intended to be
very playful, since much of the hard work making the
separations has already been done. Image Bin lends
itself to being used in a linear way – to preview a
particular set of separations with a particular palette –
as easily as being experimental or non-linear. This
blurring of the boundary between work and play,
between being structured or informal, being useful
or useless is satisfying and perhaps the real strength
of building your own tools.

<08-11>

DIGITAL PRINT

Exercises that demonstrate the layering of images.

08

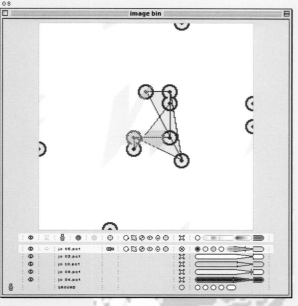

09

10

11

DESCRIPTION

PROJECT: AF SATELLITE
CLIENT: ACME FONTS, LONDON
DATE: SEPTEMBER 1998
DESIGN: CHRISTIAN KÜSTERS
TECHNOLOGY: PHOTOSHOP
FORMAT: BOOK AND POSTER
WEBSITE URL: WWW.ACMEFONTS.NET

<01>

SUPERSTRUCTURE TYPEFACE

The original font AF Carplates (used opposite for the
artist's name) was pixellated to create AF Satellite.

ACME

SUPERSTRUCTURE/SATELLITE
DIGITAL TYPOGRAPHY

The font AF Satellite was designed
for a book and poster commissioned
by the Museum for Contemporary
Arts in Zurich. The book, the
exhibition, and the exhibition poster
show the work of the British Turner
Prize nominee Angela Bulloch. The
entire project was a collaboration
between the artist and the designer.

The art is based upon a so-called
Superstructure: the artwork shown
on the cover of the book, as well as
the poster, is called Satellite with
Superstructure. The designer
interpreted the Superstructure as
being digital, hence the consciously
pixellated font. The pixels are based
upon the main font of the book, AF
Carplates (ACME Fonts).

01

<02>

SUPERSTRUCTURE CATALOGUE/BOOK

Double-page spread from the catalogue/book. The
design allows the word 'Behaviour' to loom out while
the rest of the image has been digitised.

02

VECTOR: VECTORS REPLACE THE STANDARD WEB FORMATS OF GIF AND JPEG. EXPRESSED MATHEMATICALLY, RATHER THAN BY PIXEL, THEY ARE
SMALL AND FAST TO DOWNLOAD. SINCE THEY HAVE NO FIXED RESOLUTION, THEY CAN BE SCALED AS SMALL OR AS LARGE AS NEEDED WITHOUT
IMAGE DISTORTION.

<03>

Angela Bulloch

SUPERSTRUCTURE

4. April – 14. Juni 1998
Museum für Gegenwartskunst
Limmatstrasse 270
CH-8005 Zürich
Dienstag–Freitag 12–18h
Samstag und Sonntag 11–17h

MIGROS
Kulturprozent

**Museum
für
Gegenwartskunst
Zürich**

DESCRIPTION

PROJECT: BLOOMBERG MURAL
CLIENT: BLOOMBERG
DATE: SUMMER 2001
DESIGN: ANTHONY BURRILL
FORMAT: LARGE-SCALE MURAL
WEBSITE URL:
WWW.ANTHONYBURRILL.COM

⟨01-02⟩

DIGITAL MURAL

The mural reflects the fluctuations in the stock market, using two colours, black and red, to represent profit and loss. The resulting design also suggests a city skyline.

ANTHONY BURRILL

BLOOMBERG MURAL
DIGITAL MURAL

A mural to decorate the entrance of the newly opened Bloomberg building, London. Bloomberg is a financial information provider.

Anthony Burrill's work is influenced by computer graphics and games, ceefax, cash-point machines and etch-a-sketch, among other things. Anthony would rather reduce his design options by minimising the information when a project is started. This work is visually strong both in print and in a web environment.

01

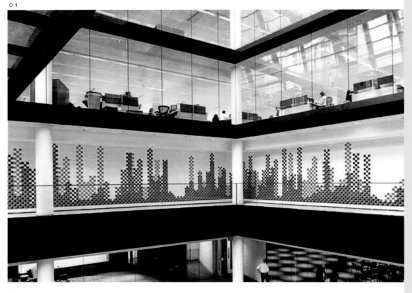

02

DESCRIPTION

PROJECT: LEVI'S VIDEO WALL
CLIENT: LEVI'S
DATE: 1999
DESIGN: ANTHONY BURRILL
FORMAT: INSTALLATION AND TYPEFACE
WEBSITE URL:
WWW.ANTHONYBURRILL.COM

<01>

VIDEO WALL

The typeface subsequently developed from the video wall installation, available to use from ACME Fonts.

01

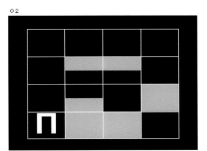

ANTHONY BURRILL

LEVI'S VIDEO WALL
INSTALLATION/TYPEFACE

The 'video wall' typeface began life as an installation in the Levi's store on Regent Street, London. Levi's commissioned Anthony Burrill to make a short film for the in-store video wall. Using the grid of the video wall, a basic typeface was drawn.

The idea was that the text could either be read as moving colours (like the disco floor in 'Saturday Night Fever') or as a series of letters, producing very low-impact 'subliminal advertising'. After the film was completed, the typeface was developed, adding in the other letters of the alphabet (and creating some pictograms). It was then made available as a usable typeface by ACME Fonts.

02

03

04

05

06

07

<02-07>

VIDEO WALL

The film was called 'wear more jeans', with the text 'wear more jeans' spelt out over the video wall in a series of looping animations.

DESCRIPTION
PROJECT: RELOAD BY LIZ FABER
CLIENT: LAWRENCE KING BOOK
PUBLISHERS
DATE: SEPTEMBER 1998
DESIGN: STATE
TECHNOLOGY: FREEHAND,
QUARKXPRESS
FORMAT: BOOK
WEBSITE URL: WWW.STATEDESIGN.COM

152

INFLUENCE

STATE

RELOAD
INTERACTIVE BOOK

Reload 'charts the progress of the search for a new visual language for the web'. It consists of a selection of 50-plus innovative websites. Visual documentation of the sites is supplemented with views and predictions from the sites' designers.

The raw material for the book was a list of URLs, together with the answers to four questions from all the sites' designers, and an introduction.

There were no easy themes to be extracted from the selection of sites. They varied from beautiful designers' homepages to anarchic, 'ugly' experimental artists' galleries.

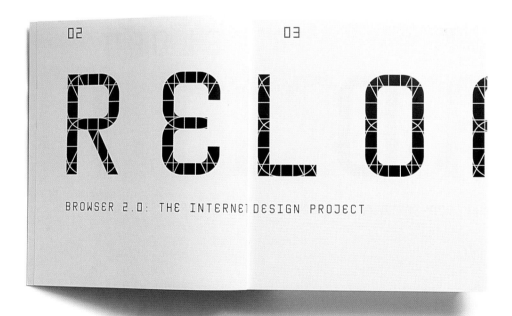

RESTART BOOK SPREADS

State selected a series of quotes from the designers' answers for their enigmatic or humorous qualities, which helped to arrange sites into loose, strangely related groups. From this method they then had seven chapters, each centred around a quote.

The page structure of the book reflects the almost arbitrary arrangement of content. There are parallels between the sequencing of sites and the experience of following a series of hypertext links.

State wanted their experience of designing the book to be a non-traditional one. The process that they adopted resulted in an aesthetic that suggests the fragmentation of web content by the browser.

Each chapter was designed as a large plane, four pages high by four pages wide. The only elements that relate directly to the ultimate page are the folios. The plane was then cut into 16 pages – eight double-page spreads.

02

03

DESCRIPTION

PROJECT: CONTAINER
ACADEMIC WORK: SELF-INITIATED
DATE: MAY 2001-JUNE 2001
DESIGN AND CONCEPT: PAUL BARON,
PAULUS DREIBHOLZ
TECHNOLOGY: FREEHAND,
NEEDLE AND THREAD
FORMAT: BOOK
WEBSITE URLS:
WWW.IN-DUCE.NET
WWW.GAFFADESIGN.ORG

PAUL BARON AND PAULUS DREIBHOLZ

CONTAINER
VISUALISING NAVIGATION

Set as a college project, Container was meant to be a website, or at least of a screen-based nature. The brief was intended to explore the possibilities of interactive media including sound, navigation and images, etc. Paul Baron and Paulus Dreibholz decided to work on the project as a team, soon realising that navigation was much more than the limited possibilities provided by digital or analogue media.

For them it had more to do with navigation through life, how we affect other people and how their navigation affects us. They developed interactive games and typographic concepts to represent Influence and Navigation and created virtual and natural three-dimensional environments that provided a stage for the developed processes. Always moving from idea to idea, always keeping a grasp of the initial thought, the pair allowed the project to develop with their daily experiences.

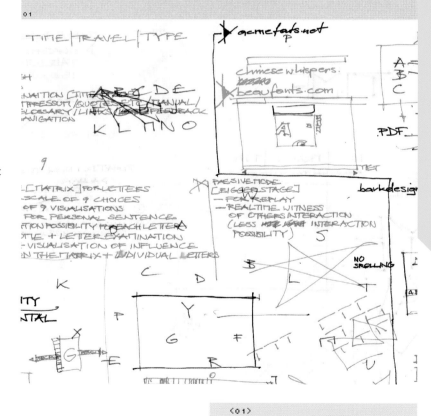

01

⟨01⟩

CONTAINER: INITIAL
WORK-IN-PROGRESS

Sketchbook development using text and image.

<02>

CONCEPT AND DEVELOPMENT

Having realised how many stages they had gone
through, Paul and Paulus decided to filter the essence
of their research and development and put it together
in a very simple but thoughtful format. The book is to
be seen like a journey document. The thread, which is
travelling through the pages, spelling out a sentence,
represents their own way through the subject matter.
It is a navigation through 'Navigation'. The content
is as far-reaching as their thoughts and initiates a
feeling of open but coherent interaction.

<03>

CONTAINER: FINAL BOOK

Paul and Paulus worked closely on every stage of
the project, starting from the idea and continuing to
the concept until the outcome was bound and the
'Thread-installation' exhibition was set up. The book
is the focus of their finals, and it is meant to be seen
as a 'notebook' or 'sketchbook' in which to present a
filtered version of their brainstorming. They describe
the work as 'the container of our navigation through
the navigation'.

03

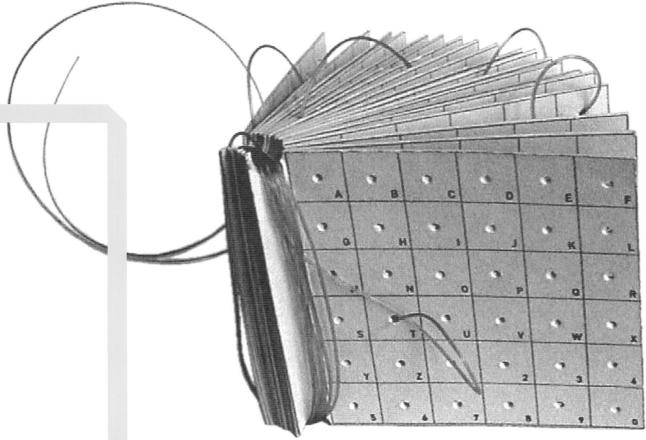

ASIDES

ADOBE ACROBAT: AN APPLICATION ALLOWING FILES TO BE READ IN THE PDF FORMAT. PDF <PORTABLE DOCUMENT FORMAT> WAS DESIGNED BY ADOBE TO ALLOW LARGE GRAPHIC FILES TO BE HIGHLY COMPRESSED FOR DISTRIBUTION VIA THE INTERNET.

AFTER EFFECTS: AN APPLICATION FOR DESIGNERS AND FILM-MAKERS TO CREATE FILMS USING THE SAME PRINCIPLES AS PHOTOSHOP — LAYERING, FILTERS, ETC.

AIFF <AUDIO INTERCHANGE FILE FORMAT>: STANDARD FILE FORMAT FOR DIGITAL AUDIO.

APPLET: A MINIATURE PROGRAM EMBEDDED INTO WEB PAGES. UNLIKE FLASH AND SHOCKWAVE, YOU DON'T HAVE TO DOWNLOAD A PLUG-IN AS IT IS WRITTEN IN JAVA.

BANDWIDTH: THE RANGE OF TRANSMISSION FREQUENCIES A NETWORK CAN USE. THE GREATER THE BANDWIDTH, THE GREATER THE POWER AND THE FASTER DOWNLOADING CAN BE.

BETA: PROTOTYPE OR WORK-IN-PROGRESS.

BIT: THE '1' OR '0' THAT MAKES UP DIGITAL INFORMATION. THE MORE BITS IN A DIGITAL IMAGE, THE HIGHER THE RESOLUTION.

BITMAP: THE DIGITAL ARRANGEMENT OF DOTS THAT REPRESENT AN IMAGE.

BROWSER: APPLICATION ENABLING INTERNET CONNECTION, EG, INTERNET EXPLORER, AOL OR NETSCAPE.

<DESIGN> PORTAL: THE FIRST PAGE VIEWED BY THE USER ON ENTERING A WEBSITE CONTAINING A CATALOGUE OF LINKS TO OTHER WEBSITES. A DESIGN PORTAL OFFERS THESE LINKS IN A VISUALLY ACCESSIBLE WAY.

DIRECTOR <APPLICATION>: DEVELOPED BY MACROMEDIA AND DESIGNED ORIGINALLY TO PRODUCE ANIMATION THROUGH BASIC PROGRAMMING, DIRECTOR IS NOW, ALONGSIDE FLASH, A SOPHISTICATED APPLICATION AND A VERY POWERFUL STANDARD IN INTERACTIVE WEB MEDIA. IT ALLOWS SOUND, IMAGES, QUICKTIME MOVIES AND OTHER MEDIA TO TALK TO EACH OTHER TO CREATE DYNAMIC WORK. DIRECTOR WORKS ON CD-ROM AND INTERNET PLATFORMS. DIRECTOR MOVIE IS A STANDALONE FILE CREATED IN DIRECTOR AND FORMS A PERCENTAGE OF CD-ROM PRODUCTION <ALSO KNOWN AS A PROJECTOR>.

DIRECTOR SHOCKWAVE <INTERNET>: SHOCKWAVE IS DIRECTOR MOVIE'S BROTHER FOR THE INTERNET. IT CAN CREATE TRULY IMMERSIVE, INTERACTIVE EXPERIENCES. DIRECTOR'S PROGRAMMING IS MORE POWERFUL THAN FLASH, SO IT IS USUALLY USED ON THE INTERNET FOR HIGHLY SOPHISTICATED USER EXPERIENCES.

EMAIL <ELECTRONIC MAIL>: MESSAGES SENT AS TEXT OR IMAGES THROUGH A NORMAL PHONE LINE VIA A COMPUTER NETWORK.

ENHANCED CD-ROM <AUDIO/DATA>: AN ENHANCED CD-ROM FORMAT COMBINES DATA AND AUDIO FILES THAT CAN BE ACCESSED FROM THE SAME CD. THE CD CAN BE PLAYED FROM A STANDARD CD PLAYER AND THEN LOADED ON TO A COMPUTER TO VIEW VIDEOS AND MORE INFORMATION.

FLASH: STANDARD WEB SOFTWARE FOR DESIGNERS AND PROGRAMMERS TO BUILD COMPLETE WEBSITES. FLASH HAS ALLOWED DESIGN TO FLOURISH, AS THE APPLICATION IS BUILT SO THAT TYPOGRAPHY AND IMAGES CAN BE VIEWED AT HIGH SCREEN-BASED VECTOR RESOLUTIONS, RESULTING IN CLEAN GRAPHICS AND RICH COLOUR PALETTES.

FONT: THE DESCRIPTION OF THE SIZE, WEIGHT AND SPACING OF A CHARACTER. IN TYPOGRAPHY WE HAVE FONTS AND TYPEFACES. THESE ARE DIFFERENT — THE FONT IS A CHARACTER'S FORMAT, FOR EXAMPLE, 'TIMES 24-POINT ITALIC'; AND THE TYPEFACE DESCRIBES THE STYLE, FOR EXAMPLE, 'TIMES'.

GENERATIVE GAME: A GAME THAT PLAYS ON ITS OWN AND HAS BEEN PROGRAMMED TO BEHAVE IN ITS OWN MANNER WITH NO USER INPUT — YOU COULD SAY THAT A GENERATIVE GAME IS SIMILAR TO A SCREENSAVER.

GIF <GRAPHIC INTERCHANGE FORMAT>: AN IMAGE FILE NAME THAT IS THE COMMON FORMAT FOR IMAGES TO APPEAR ON THE WEB.

HEXADECIMAL: NUMBER SYSTEM BASED ON THE NUMBER 16 USED IN COMPUTER PROGRAMMING TO REPRESENT COLOURS ON THE WEB. LETTERS A–F ARE USED IN ADDITION TO NUMBERS 0–9.

HTML <HYPERTEXT MARK-UP LANGUAGE>: THIS LANGUAGE OF COMPUTER CODE DESCRIBES THE HYPERTEXT PAGES THAT ARE CREATED FOR USE ON THE WEB. HTML FILES ARE VIEWED THROUGH A WEB BROWSER, FOR EXAMPLE, INTERNET EXPLORER OR NETSCAPE.

HYPER: A TERM THAT DESCRIBES LINKS BETWEEN IMAGES AND TEXT ON THE INTERNET.

INTERFACE: A SYSTEM THAT PROVIDES THE USER WITH INFORMATION IN VARIOUS FORMATS FROM WHICH THE USER SELECTS. WE CAN ALSO INTERFACE WITH MEDIA AND BE IN PHYSICAL CONVERSATION WITH IT.

INTERNET: A CONNECTION OF TWO OR MORE NETWORKS.

JAVA: A PROGRAMMING LANGUAGE.

JPEG: AN IMAGE COMPRESSION FORMAT.

LINKS: HYPERTEXT CONNECTIONS BETWEEN WEBPAGES.

MICROSITE: A SMALL SITE HOUSED INSIDE A LARGER SITE. THIS CAN TAKE THE FORM OF A GAME, AN ADVERT, OR EVEN A SPACE TO DEVELOP IDEAS AWAY FROM THE NORM.

MIXED-MEDIA INSTALLATION: MIXING DIFFERENT MEDIA — SOUND, GRAPHICS, PERFORMANCE — IN AN EXHIBITION SPACE. PROJECTORS AND SENSORS ARE AMONG THE MANY TOOLS USED TO CREATE THE EXPERIENCE.

MOBILE NETWORK: LOCATION IS NO LONGER AN ISSUE WITH MOBILE COMPUTERS <LAPTOPS>. NOW A MOBILE NETWORK IS POSSIBLE VIA NEXT-GENERATION PHONE NETWORKS — IT IS POSSIBLE TO GO ONLINE VIA ONE'S MOBILE PHONE ANYWHERE.

MPEG: AN INTERNATIONAL STANDARD DATA FILE FOR VIDEO COMPRESSION.

NAVIGATION: MOVING BETWEEN WEBSITES AND INTERNET-BASED INFORMATION, EITHER IN A DIRECTED OR RANDOM FASHION.

NETWORK: A COMPUTER LINKED TO OTHER COMPUTERS IN ORDER TO GIVE ACCESS TO ONE ANOTHER.

NEWSGROUP: A NAME GIVEN TO INTERNET DISCUSSION GROUPS DEDICATED TO SPECIAL PROJECTS.

ONLINE COMMUNITY: AN ONLINE SPACE WHERE PEOPLE GET TOGETHER TO CHAT ONE-TO-ONE OR CONVERSE IN DISCUSSION GROUPS.

ONLINE RETAIL: INSTANT SHOPPING VIA THE INTERNET WITH CASHLESS SECURE TRANSACTIONS AND USUALLY SHORT DELIVERY WAITS. STILL IN ITS INFANCY BUT ALREADY SUCCESSFUL, MANY MAJOR ADVANCES ARE LIKELY TO HAPPEN IN THE NEAR FUTURE.

PALM PILOTS: HANDHELD COMPUTER THAT CONTAINS SELECTED FEATURES OF A FULL-SIZE COMPUTER.

PDF (PORTABLE DOCUMENT FORMAT): A FILE FORMAT THAT IS CREATED IN ADOBE ACROBAT AND MAINTAINS THE ORIGINAL RESOLUTION OF IMAGE AND TEXT. THIS MEANS THAT THE IMAGE REMAINS SHARP BUT LOW IN FILE SIZE.

PIXEL: THE SMALL SQUARE DOTS THAT IMAGES ARE MADE UP OF ON A COMPUTER SCREEN. THE NAME REFERS TO HOW MONITORS DIVIDE THE DISPLAY SCREEN INTO THOUSANDS OR MILLIONS OF INDIVIDUAL DOTS DEPENDING ON THEIR VIEWING RESOLUTION.

PLATFORM: WHEN DESIGNING A WEBSITE, DEVELOPERS AND DESIGNERS NEED TO KNOW WHAT PLATFORM THEY WILL BE DESIGNING FOR (LIKE NEEDING TO KNOW THE SIZE OF PAPER IN PRINT DESIGN). IT IS IMPORTANT THAT ALL DESIGNS ARE PLATFORM-COMPATIBLE, AS DIFFERENT WEB BROWSERS DISPLAY INFORMATION DIFFERENTLY DEPENDING ON WHICH PLATFORM IS USED. 'PLATFORM' DESCRIBES THE TYPE OF MACHINE AND OPERATING SYSTEM THAT YOU USE, EG, MAC OS.

PLUG-IN: A PLUG-IN ADDS EXTRA FUNCTION. FLASH AND SHOCKWAVE ARE PLUG-INS REQUIRING THE USER TO DOWNLOAD AND STORE THEM BEFORE THEY CAN VIEW PAGES USING THESE PLUG-INS. THEY ARE USUALLY FREE.

PREMIERE: A FILM EDITING APPLICATION SIMILAR TO AFTER EFFECTS.

PROTOTYPE: USEFUL AS A MEANS TO EXPRESS AN IDEA AS A MODEL, OR AS A PROJECT SCENARIO.

QUICKTIME: A VIDEO AND ANIMATION APPLICATION DEVELOPED BY APPLE. SUPPORTING FORMATS INCLUDE JPEG AND MPEG. A STANDARD APPLICATION FOR VIDEO FORMAT.

REALPLAYER: AN APPLICATION FOR REALTIME (INSTANT) STREAMING OF AUDIO AND VIDEO FILES.

R&D (RESEARCH AND DEVELOPMENT): TIME SET ASIDE BY A COMPANY FOR TESTING NEW IDEAS AND DEVELOPMENTS.

SEARCH ENGINE: ALLOWS THE INPUT OF KEY WORDS IN RELATION TO INFORMATION YOU ARE LOOKING FOR, WITH WHICH IT CAN SEARCH ITS OWN DATABASE OR OTHER SEARCH ENGINES TO PROVIDE FEEDBACK.

SHAREWARE: A SOFTWARE PROGRAM FREELY AVAILABLE ON THE INTERNET.

SOUND TOYS: SOUND/AUDIO APPLICATIONS DESIGNED TO ENHANCE THE USER EXPERIENCE OF INTERACTING WITH SOUND. THEY ARE USUALLY SMALL APPLICATIONS THAT CAN BE PLAYED OVER THE INTERNET.

STREAMING: WE CAN DOWNLOAD FILMS AND MUSIC FROM THE INTERNET, BUT SLOW INTERNET CONNECTIONS AND LONG DOWNLOAD TIMES PUT USERS OFF DOWNLOADING LARGE FILES. STREAMING ENABLES SMALL SECTIONS OF A DATA FEED TO BE DOWNLOADED AND ACCESSED FOR PLAYBACK IN STAGES – AND THEREFORE PLAYS THE DATA WHILE DOWNLOADING.

STREAMING MEDIA: STREAMING IS DESIGNED SO THAT THE USER IS ABLE TO SEE OR HEAR A FILE AS IT IS BEING DOWNLOADED. RATHER THAN NEEDING THE ENTIRE FILE, THE COMPUTER IS ABLE TO ACCESS PARTS OF THE FILE AS IT IS ARRIVING. REALPLAYER, QUICKTIME AND WINDOWS MEDIA ARE THE COMMON STREAMING APPLICATIONS AVAILABLE, AS WELL AS INTERACTIVE STREAMING IN FLASH AND DIRECTOR SHOCKWAVE.

TESTING: AS THE INTERNET IS A CROSS-PLATFORM SYSTEM, DEVELOPERS NEED TO TEST THEIR DESIGNS ON A VARIETY OF MACHINES AND BROWSERS SO THAT THE FINAL SITE CAN BE VIEWED BY ANYONE, ANYWHERE.

TIFF: A PRINT GRAPHIC FILE FORMAT.

TIME-BASED MEDIA: THIS IS SIMPLY MEDIA THAT INVOLVES TIME AND THEREFORE HAS A BEGINNING AND END – OBVIOUS EXAMPLES BEING FILM AND MUSIC.

URL (UNIVERSAL RESOURCE LOCATION): IDENTIFICATION ADDRESS OF RESOURCES ON THE INTERNET. URLS LOOK LIKE THIS: WWW.INTERACTIVEWEBBOOK.NET

VECTOR: VECTORS REPLACE THE STANDARD WEB FORMATS OF GIF AND JPEG. EXPRESSED MATHEMATICALLY, RATHER THAN BY PIXEL, THEY ARE SMALL AND FAST TO DOWNLOAD. SINCE THEY HAVE NO FIXED RESOLUTION, THEY CAN BE SCALED AS SMALL OR AS LARGE AS NEEDED WITHOUT IMAGE DISTORTION.

WEBSITE (OFFLINE): A WEBSITE THAT NO LONGER WORKS ONLINE, OR HAS BEEN TAKEN OFFLINE. OFFLINE CAN ALSO MEAN A TESTING SPACE, OR A SITE IN DEVELOPMENT.

CONNECTIONS

Like all ideas, this book is something that I have had to share and live with for a year, something that had to be articulated with words. I have never found writing easy (it stressed me out at college) and writing this book has been a difficult process as I struggled to describe the internet and interactive physical/digital experiences engaged with by hand and mouse. Talking about it freely with friends over a beer or via email is familiar and easy but, as a designer, this new space of writing has tested my limits.

Much of what I am trying to articulate here only became clear when I began to engage with fellow designers on the subject. I would like to thank all the contributors to the book for broadcasting their ideas and thoughts, and allowing me to feature their work in this space.

This book is about a layering of creative energies and skills and its underlying concept is collaboration – whether you are a programmer, designer, architect or thinker, we all at some point interact and engage with each other.

First of all I would like to thank my dear friend Gareth Langley, who provided an excellent essay on how programmers and designers work together. Gareth introduced me to the possibilities of what programming can be, and without his input from early on, I don't think I would have written this book.

Thanks to Toshio Iwai – from an early age his work inspired me to consider interface design beyond the square monitor and that it can be experiential. It feels like game design mixed with fine art and the music of Brian Eno.

Thanks also to Giles Rollestone, who has spent many an hour over a glass of red wine and a bowl of pasta with me. His work encompasses the role of passivity in interaction design, allowing ambient spaces to be created that mean that CD-ROM design isn't just glorified PowerPoint presentations, but work that is beautiful in essence. The experience of the work feels like I have been to Tokyo and back to the UK simply by double clicking the launcher, kind of like an interactive audio album.

Thanks to Method for demonstrating that a site can be made to look good and work simply by using HTML and a good understanding of typographic hierarchy. Halfway through the project I despaired of finishing it at all. It wasn't until my friend Christian Pollax had flown in all the way from Germany to show me work that he wanted to put in the book that I recalled why I began this book in the first place. Christian's browser designs for Medusa made me rethink my concepts and gave me impetus to start again.

Thanks to Anthony Burrill for bringing back memories of childhood through his simple, humorous artworks, and to: Stefan Brandy, Colin Hughes, James Tindall, Colette and FlipFlopFlyin, NOWWASHYOURHANDS, Less Rain, Nat Hunter at Airside, Nima Falatoori, Danny Brown, designobject, Joe Berger, Intro, Digit, Tota Hasegawa, Future Farmers, State Design, Ian Mitchell, Hitch, LettError, Christian Küsters, Paul Baron and Paulus Dreibholz.

The pixellated typeface used in this book was designed by Ian Mitchell, who is featured in the Influence essay – thanks for the freebie.

Thanks to Giles Lane – the only person who understands what I'm trying to say in note form and doesn't get exasperated when I can't explain myself properly. Thanks also to Nima for those late nights compiling my thoughts at the last minute.

Thanks as well to those who were so busy either moving studio or being creative: Tomato Interactive, John Maeda, Rudy Vanderlans, and the Mind the Banner Project.

And finally to Kate Noël-Paton, for inviting me to write this book in the first place and for encouraging me to eventually finish it, thanks…

SELECTED BIOGRAPHIES

BUILDING MEDUSA:
A SCIENTIFIC APPROACH TO A
CREATIVE PROCESS IN DESIGN
CHRISTIAN POLLAK

During and after his studies, Christian worked as a
freelancer for several design and consulting agencies
such as MetaDesign, Wolff Olins and Pixelpark. From
February to December 2001 he was employed as New
Business Consultant for a small German software
company specialising in media asset management.
Combining his academic interest of innovative
information structuring with his work experience
in branding he brought forward topics like corporate
brand processing and brand resource management.
The projects stretched from editorial systems
to applications for interactive television and
three-dimensional environments.

SUSHI: NETWORKED INFORMATION
SERVICES IN CONTEXT-SENSITIVE
ENVIRONMENTS
GILES ROLLESTONE

Giles graduated in the early nineties in a period of
economic recession and social transition. The nature
of graphic design as a profession was in a state of flux.
There were paths to follow in either print-orientated
graphic design or interactive multimedia. He chose
to embark on a journey into a world of non-linear
film, music and hypermedia, working exclusively in
experience design; the blend of form, behaviour,
content and context.

LINGO LAVALAMP:
CREATIVE PROGRAMMING
GARETH LANGLEY

Gareth Langley is a partner with Stardotstar, who
formed in 2001. Gareth had worked in industry since
1994 and as a freelance developer for the previous four
years. He explains, 'multimedia development and
programming can be just as creative as painting on
canvas. Having our own company allows us to push the
experience of interaction between the user and our
interface to truly engage people to explore each and
every avenue of a given piece of work.' Stardotstar's
client list crosses from TV to corporate to the arts,
having created work for people like Channel 4,
Warburtons and Gallery Oldham, among others.

RESEARCH AND PLAY
DEVELOPS CREATIVE THINKING
PAUL FARRINGTON

StudioTonne's output covers publishing, interactive
media and design for print for clients including Channel
4, Big Heart Media, IDEO, RCACRD, Bip Hop Records
and Grizedale Arts, among others.

They also develop and produce controlled systems
for sound and image interaction. Earlier work includes
visuals for Scanner, Springheel Jack, Pole and
Monolake. StudioTonne provides visuals for its own
music; their first release gained interest from Bip Hop
(France), Mille Plateaux (Germany) and Schematic (US).
The studio has tracks on the forthcoming Bip Hop
Generation [v.5], and a unique audio/CD-ROM-
enhanced release is scheduled for early 2002 on Bip
Hop. Mille Plateaux released 'Uncoated' on their MP3
magazine in September 2001. StudioTonne has
performed at the Splitski New Media Festival (Croatia),
Sonar (Spain), FCMN (Canada), Expanded Cinema
(Italy), Lovebytes (UK) and Steim (the Netherlands).

MGCADT
LIBRARY